William Gardner's Book of Calligraphy

Wildwood House

First published 1988 by
Wildwood House
Gower Publishing Company Limited
Gower House, Croft Road
Aldershot GU11 3HR

Gower Publishing Company
Old Post House
Brookfield
Vermont 05036
USA

British Library Cataloguing in Publication Data

Gardner, William
 William Gardner's Book of Calligraphy.
 1. Calligraphy
 I. Title
 745.6'1

Library of Congress Cataloging in Publication Data

Gardner, William
 William Gardner's Book of Calligraphy.
 P. CM.
 Bibliography: P:
 Includes Index.
 1. Calligraphy. I. Title. II. Title: Book of Calligraphy.
 Z43.G22 1988
 745.6'1--DC1988-4000
 CIP

ISBN 0 7045-3101-1

In gratitude to
Sheila Gardner, enthusiast

Contents

Preface

I begin by paying tribute to the two craftsmen who revived interest in Western calligraphy. William Morris, as well as exercising his other skills, probed the history and practice of the craft at a time when others felt it to be irretrievably lost or not worth consideration. And Edward Johnston, inspired by Morris's pioneering work and encouraged by Lethaby, explored and analysed penmanship to such good effect that his teaching and his book of 1906 established calligraphy in its own right and brought about its European revival. Johnston, advised by Cockerell, concentrated upon English tenth-century (Winchester) penmanship as his model, updating it for twentieth-century use.

For success in calligraphy it is the pen which must dominate the scribe's performance. Writing to Irene Ironside about the broad nib, Johnston provides a reminder of this:

This brings me to the distinction of thicks & thins: this distinction is in itself strongly conducive to uniform strokes & shapes (as these are largely controlled by the pen itself) such a

And again:

> As a sufficiently simply made example of the "Square" R. Cap. writing is not obtainable, this should be created by the pen. (see MaI.7.(1))

And yet again, regarding a further group of examples of written capitals for use with the small letter varieties; 'all are made correct by the pen.' Johnston convincingly points out that the broad pen 'is essentially a letter-making tool . . . it may therefore be relied upon largely to determine questions of form in letters . . . in fact, a broad nib actually controls the hand of the writer and will create alphabets out of their skeletons, giving harmony, proportion and character to the different letters.' Submission to its demands does not exclude freedom of action – an apparent contradiction but something which experience constantly affirms. It is a love affair which at length matures into a disciplined emancipation, the price being dedicated and constant application to every aspect of the skill. It has to be experienced personally and the maturer stages of the relationship are what this work is about.

Ben Shahn struck the right note for all time in the title of his book *Love and Joy about Letters.* There is a long apprenticeship in letter forms to be worked, a process in which at times one seems almost to take two steps back for every one forward. Such a novitiate, involving the making of thousands of **A**s, thousands of **B**s and thousands of **C**s, gradually

allows the pen strokes of which the letters are composed to crystallize more acceptably (inching slowly towards perfection), until an accomplished hand, having mastered its basic drills, will carry the scribe over the threshold into a relaxed and efficient state where he is free to make instant judgements, and where energy is directed into assured creative action. No longer will each aspect of every stroke need anxious consideration. Decisions will be swift and stimulating. Such work will possess unmistakable cachet; perhaps only the initiated will recognise the solutions to a stream of problems which arise during the course of a manuscript work, but the professional sense of enterprise and daring will be manifest. The calligraphy will be of well-made letters written unhesitatingly and assembled consecutively and rhythmically into words. The strokes will be sharp, and they will be formed with a consistent pressure and done at a speed fast enough to maintain a steady sense of direction from one end of the stroke to the other. This will be combined with restraint in the matter of flourishes and other tempting extravagances.

The steady flow of ink from a well-trimmed quill pen in contact with prepared vellum is an incomparable experience, as rich tactually as needleworking with silks and gold thread. The characteristic ambience of the vellum mingled with the fragrance of stick-ink enhances a euphoria which assists the quality of the writing itself. One is carried along by what the pen is doing and dare not

for a moment contemplate failing to live up to the challenge. Even the regularity of pauses to refill the pen becomes a rhythm chiming in with that of the letter-flow itself.

Accomplishment in a modern bookhand will depend on many factors, all of which I shall discuss in turn – familiarity with sources, experience, materials and instruments, physical comfort and mental tranquillity, co-ordination of eye and hand, urgency tempered with restraint, the subject-matter, the purpose, and the length and scale of the work.

We are distant enough from Edward Johnston's day to listen with particular relish to his thoughts on calligraphy for the young from his illustrated notes 'On Children Using Varieties of Formal Penmanship', and related correspondence, still unpublished. We are very much indebted to Irene Ironside, who, as a young graduate of the Froebel Educational Institute, Roehampton, had the vision to seek professional guidance from Edward Johnston in her teaching children the essence of the art of the pen. She became in this way the recipient of much vital instruction during the war years 1914-18. Correspondence between Miss Ironside and Edward Johnston was supplemented by tutorials, some of them over restaurant tables at Victoria Railway Station.

Encouragement was always the essence of Johnston's tuition.

I am most anxious not to _discourage_ you, or anyone: I dont think there is any difficulty that a good heart will not overcome.

Insufficient time for practising, it being "too late" to begin to learn: such disqualifications are not final, we may not attain to a high technical skill under them, but they cannot prevent us from making things which are good & pleasant. On the other hand, time "& practising" cannot unaided do this, but a good will will make the most from the least.

I distinguish between "practising" which involves the idea of time & teaches only itself, ~~it not~~ X _practice_ which is the act of making & teaches us _how to make_.

Forgive all this if you find it too sermon like. I am trying to tell the' Truth that I know. ℰℐ.

I confess to my own enchantment and inspiration, experienced long ago with other students in that design studio during those never-to-be-forgotten visits by the great scribe to the Royal College of Art.

And I pay warmest tribute to my other teacher, the letterer and scribe Mervyn Oliver, hardest yet kindest of taskmasters in this most rigorous of disciplines. I was afterwards profoundly grateful that during my apprenticeship with him he successfully urged me to see, and sometimes turn the leaves of, breathtaking manuscripts in the national collections.

It is a privilege, in turn, to have been a teacher of penmanship to so many students and enthusiasts from whose countless practical queries my own work in turn has benefited.

William Gardner

Acknowledgements

Besides my late wife, who so closely shared this whole project with me, it is a pleasure to acknowledge the kindnesses of the many who provided me with immeasurable help. I am especially indebted to my editors James Price and Stephen Ryan, to Sybil Weir and Jill Gardner for secretarial help, and to A. Vaughan Kimber for photography. Also, I am deeply grateful to Christopher Ironside for access to the correspondence from Edward Johnston to Irene Ironside (now located in the Victoria and Albert Museum Library, MS.L. 4–1988), and to Geoffrey de Bellaigue, John Dreyfus, Anthony and Molly Thomas, John Body, Henry Band, Andrew and Godfrey Gardner, Violet Luckham and Kate Smallbone for individual help in a variety of ways. I must acknowledge as well much assistance from the Lord Chamberlain's Office, Windsor Castle, the staff of the British Library, the Victoria and Albert Museum Library, the University of Cambridge Library and the Monotype Corporation.

Penned examples are by the author. Figures 1 and 320 are from Sir Edward Maunde Thompson's *An Introduction to Greek and Latin Palaeography* (Oxford, 1912). Figure 349 is by courtesy of the Victoria and Albert Museum. Figure 331 is from Jean

Porcher's *French Miniatures from Illuminated Manuscripts* (London, 1960). Plates 6 and 7 are by courtesy of Cambridge University Library. Figure 321 is from S. Harrison Thomson's *Latin Book Hands of the Later Middle Ages* (Cambridge, 1969). Figures 324 and 325 are from A. Osley's *Mercator* (London, 1969). Figure 318 is from *Writing, & Illuminating, & Lettering,* by Edward Johnston (Hogg, 1906).

And it goes without saying that the subject could hardly have been pursued without the experience of commissioned work over the years, while much of the discussion arises from searching questions by the many students whose course work I have been privileged to supervise.

Introduction

It was the square-ended writing tools adopted by scribes – reed upon papyrus and later a bird's quill upon the skins of animals – which, above all other writing instruments in Europe, dictated the current alphabetic image. Of course, contributions were made by chisel, graver and brush, but by far the greatest influence upon current letter form has been that of the square-ended pen.

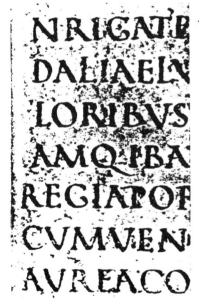

(1)

The models for the monastic penman engaged in multiplying the manuscripts that carried the Christian message were the later stone inscriptions of the Roman Empire. Square capitals (*Capitales Quadratae*) (1), along with a variant also known in stone (*Capitales Rusticae*), were the penman's natural portrayal of roman inscriptional letter-cutting. The structure of such a capital alphabet is the concern of the first section of Part I of this book. The penman's square capitals were followed by what we now call uncial book script, comprising rounded, penmade capitals. Uncial is the subject of the second section of Part I.

By the fifth century A.D., uncials had evolved into the half-uncials, with ascending and descending stems, which later assumed the forms of mature minuscule styles in different national varieties.

Of all the European scripts evolved since the

break-up of the Roman Empire, the Carolingian is for us the most significant. It sprang from Charlemagne's literary reforms of the late eighth century and his encouragement of the development of a national script at the Abbey of St Martin at Tours. As in other writing reformations, this one involved a return to classical modes. The Carolingian script is a rounded, pre-eminently practical and beautiful style of writing, entirely at one with the potential of the square-ended pen. It affected virtually all European scriptoria, not least that of the English community at Winchester. While writing styles in the main developed independently, they were affected by scripts of other localities; for books containing these, being small and readily portable, were undoubtedly seen far from their place of origin. The scriptoria of the Continent were influential in Britain and manuscripts from Ireland, Durham, Canterbury and Winchester affected not only indigenous work but Continental practice as well.

Seven centuries after its development, Carolingian became, in modified form, the model for the early printers. (It was known, loosely, as 'roman' and, perhaps more specifically, as 'venetian' – from that early centre of its printed use.) Four centuries later still, Edward Johnston revived the Carolingian bookhand, or rather the tenth-century Winchester version of it, as his foundational or basic script. It would not be too much to claim that this revival, through the widespread teaching of Johnston's

followers and an enlightened private press fraternity, effected a purging of letter form throughout Europe.

Variants of Johnston's revived basic script are still practised today, almost a century later. Although scripts, unlike type faces, are always on the move, one can acknowledge the main similarities between twentieth-century basic minuscule hands, since they are inherently restrained from pushing their differences beyond the bounds of recognition. The form of modern penmanship is in this way largely looked after. The minuscule alphabet whose structure is detailed in the third section of Part I of this book is essentially Edward Johnston's revived Winchester bookhand.

We have few personal accounts of the practice of penmanship from scribes of the remote past, who were mostly unnamed clerics. (The modern *sofer,* or writer of the Hebrew Pentateuch, is a descendant.) Among a very few exceptions there is the deposition of Godeman the Scribe, who wrote the incomparable late-tenth-century manuscript known as the 'Benedictional of St Aethelwold', now in the British Library (Add. MS 49598). Godeman's bookhand is an outstandingly beautiful example of Carolingian script. He provides a colophon of golden letters in which he tells in poetic language the circumstances of the commission and his attitude to it. But, whether it was beneath the nature of the occasion or from a craftsman's instinctive reticence, there is no technological comment. Even Theophilus Rugerus, the early-eleventh-century

monk, and writer of the famous *Treatise upon the Various Arts,* omits penmanship, although gold ink and encaustum are touched upon in passing. In Parts III and IV, I have attempted to provide just such a personal account, detailing the main practical requirements of penmanship (Part III) and some of the conditions, both of the scribe and of his working environment, that are necessary if that tranquillity is to be achieved which is a prerequisite of fine penmanship (Part IV).

Practising scribes of today are deeply indebted to twentieth-century palaeographers – Thompson, Ker, Wormald, Dodwell, Millar, Alexander, Jenkinson, Brown, Parkes and others. However, modern scribes have on the whole neglected or not recognized the potent source of criticism of their practice provided by the profession of palaeography. I hope that the particular recognition given here will help to rectify the general neglect. This matter is discussed further in Part V, and some of the devices by means of which copying errors described by palaeographers can be avoided are described below (pp. 141 and 169) and are in current use.

Because the pen has had such a profound influence on the alphabetic image (see beginning of introduction), typographers and printers today (though printers have for over five centuries wrestled with problems concerning the form and arrangement of letters, and diligent scribes will pay attention to their findings) must still defer to images

deriving from penmanship, and they are likely to continue to need to do so. Modern printers have indeed paid tribute to the penman's art. In *The Ideal Book or Book Beautiful,* Thomas James Cobden-Sanderson, the Doves Press binder, testifies to the essential relationship between calligraphy and typography: 'every printer and indeed everyone having to do with the making of books should ground himself in the practice or knowledge of the Art of Beautiful Writing or Calligraphy . . . such practice would keep Type alive'. He goes on to advocate 'in association with the Printing Press a Scriptorium where beautiful writing may be practised and the art of letter designing kept alive'. And only very recently, the typographic historian John Dreyfus has claimed that scribes still have an influential role to play in today's field of printed book production. Conversely, scribes are indebted to the scholarship of printing historians and incunabulists – Scholderer, Proctor, Dunn, Lyell, Morison and many others. Their classification of the earliest printers of books – those who had personally usurped a still active penmanship by means of mechanically produced scripts of the day – has contributed to our appreciation of European fifteenth-century bookhands. In Part V, the relationship between calligraphy and typography is touched upon under the aspect of the loss of 'verve' involved in the mechanization of calligraphy (see p. 165).

The serious calligrapher should recharge his

batteries periodically by looking at the great surviving manuscripts exhibited in the national collections. The sight of such scripts, some of them carried out more than a thousand years ago, undoubtedly serves to put adrenalin into the ink of the modern scribe. (See Bibliography.)

Constant observation, note-taking and sketch-book filling are the marks of the scholar-craftsman. To be steeped in the art is a part of penmanship. The skilful pen is one that finds itself happily in the hand of a willing collaborator – one sensitive of its never-ending capabilities, refinements and irresistible demands.

Part I: STRUCTURE

Basic capitals

In finding inspiration from the roman alphabet, whatever the pen may dictate as to thickness of stem or the form of the commencement and termination of stroke, it is bound to defer to the general proportions of the roman letters or be unroman. In our roman alphabet, **A B E F I J K L P R S (T) V X Y** may be seen as narrow letters, and **C D G H M N O Q (T) U W Z** as wide ones. It would be uncharacteristic in the best roman inscriptional work to find **E**s and **H**s, **Q**s and **S**s all of equal width. To dragoon all the capital letters into rectangular areas of the same proportions, as in old standard typewriter styles (and certain type faces), might in some circumstances be technically convenient, but it would be to subvert what we are concerned with here: the characteristic subtleties and beauties of roman letter form as interpreted through penmanship.

It will be convenient here in providing a description of the structure of our penmade alphabe to stick to the order of the alphabet as we know it, and in the written examples to envisage horizontal guide-lines — such lines having been scored into stone and ruled onto vellum from earliest times.

The roman letter-cut **A** derived its directional stress

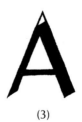

A

(2)

A

(3)

from the use of a square-ended instrument; possibly a layout brush of papyrus fibres, held in the right hand, and trailed over the stone for the carving to follow. All penmade letters that have diagonal strokes made downwards from top left to bottom right – **A M N V X** for instance – made as they are, with the pen's working-edge at a constant angle of about 30° from the horizontal, exhibit this characteristic difference in directional stress. In the case of **A**, the difference in stress between its first and second strokes will be substantial. In forming **A**s, the horizontal third stroke is best kept well below the letter's apex (2); otherwise the contained triangle of background will reduce sharply and lose value. I suggest it be placed where it will be in visual balance: its own thickness below a point halfway between the upper and lower guide-lines.

Beginnings and endings of letter stems are important. There are three ways in which the top junction of **A** may be properly and efficiently formed. First, there is the top that the pen's 30° working-angle will straightforwardly secure (2). This overlapping hinge must be done convincingly: each down stroke must start from precisely the same place. If a pointed top is preferred, this should be added while the ink is still wet, using the pen's left corner to carry the wet ink very slightly above the upper guide-line (3). Such a projection will counteract the tendency for **A** to look shorter than other letters in a sequence. The second top is formed by a curved beginning to the second stroke that

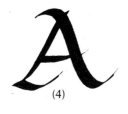

(4)

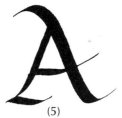

(5)

(6)

(7)

(8)

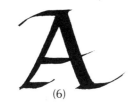

(9)

overlaps the lighter weight left-hand member. It is then brought smoothly down as **A**'s main stem (4). Its commencement may be either at the top guide-line or at some distance above (5), according to how much room there is and whether or not it is an initial **A** (if it is, it need not conform to the height of the letter sequence).

The third top for **A** is less often used. This is formed by a short horizontal stroke made close under the top guide-line (6). This kind of stroke may also be used either to terminate both of **A**'s feet or, where the right one finishes in a curved sweep outwards, to end the left stem at its inner angle.

Finally, to retain the character of **A** (remember it is traditionally one of the narrow letters) the angle contained by its stems should not be increased or decreased beyond what has been acceptable over the last two thousand years; that is, not (7) or (8), but somewhere between (4).

Capital **B** (9), which, like **A**, is a narrow letter, consists of two lobes added to the right of a vertical stem. It is not unlike two **D**s, one above the other, the upper one being the smaller of the two in keeping with an apparently universal horror of anything approaching top-heaviness. Like those rocking toy figures with lead weights at the bottom, letter **B** should come to rest, buoyant and erect. The commencement of B's main stem may remain uncovered after the second stroke has crossed it: such things are acceptable as part of the craft and

B

(10)

have nothing to do with untidiness. But if its effacement is desired, the scribe should begin the main stem low enough for the beginning to be covered completely by the second stroke.

The base of **B** will be marred if the short third stroke fails to aim perfectly to meet the second part of the broken stroke; a meeting which should be both razor sharp and accurate (the eye will automatically bridge any tiny gap inadvertently left) (10). Failure in this is unacceptable; only practice can ensure its achievement.

The crisp formation of letter **B** will be forwarded greatly if the broken second stroke does no more than (or even does not quite) touch the main stem. As in the construction of **K** and **R**, to form a clumsy nodule by running the stems into one another is inexcusable (47).

In detailing the construction of capital letter **B** (and those of **D E L** and **Z**) it has been assumed that the stroke that forms the main stem will end on the completion of that stem. However, it may, without the pen's being lifted, continue to the right and complete the lower member as the last part of one broken movement rather than leave it to be completed by a further, separate stroke.

(11)

The capital and minuscule forms of **C** are similar (11). **C** is to a substantial degree like a letter **O** that has lost something like the middle third of its right-hand stroke. The ending of **C**'s upper member is a feature requiring especial care (see also **G** and **S**, in

modified form **E** and **F**, and minuscule **c**, **r** and **s**). It is formed by a three-dimensional movement that requires much practice to perfect. At the appropriate moment in the making of the second (top) stroke, the right-hand corner of the pen is lifted from the writing-surface and the pen's left corner is allowed to proceed fractionally further, dragging the ink into a pleasantly characteristic 'beakhead' (12): an elegant shape that is well worth cultivating. Although, of course, there are other endings – lifting the pen straight away from the writing-surface as it halts at the end of the stroke (13), for example, and then perhaps adding a short line in one direction or the other (14, 15, 16) – they are less effective: a true beakhead is the most accomplished ending.

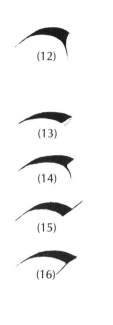

(12)

(13)

(14)

(15)

(16)

(17)

It is a characteristic of the formation of letter **C** (as well as those of **E K L Q R T X** and **Z**) that where the ending is prolonged enthusiastically, the right-hand corner of the pen may fail to lift soon enough from the writing-surface at the thinnest point of the terminal stroke, dragging with it a small amount of ink which forms a minute triangle (17). This is quite acceptable; indeed, provided that it remains slight and is not featured overduly, it is something to be enjoyed and appreciated, and is evidence of speed and panache in the penmanship.

At the top of **C**, where the letter is at one of its thinnest places, the two stems which begin there and move away from each other should align impeccably. As with **B**, true placement of these two stems does not necessarily demand that their sharp

ends quite touch. The eye will bridge a tiny gap if the alignment is perfect.

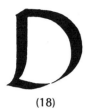
(18)

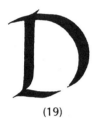
(19)

Capital letter **D** is one of the most visually satisfying letters and one of the most difficult to make well. It is a combination of letter **I** with something more than the right-hand part of letter **O** (18). It may also be thought of as, in part, a reversed letter **G** with the stress transposed.

D's lowest stroke, which begins against the outward-turning base of the main stem, aims its sharp end to coincide with that of the second (downward-curving) stroke.

There are two alternative tops to **D**: an identical point of departure of the two strokes involved (18); and a refinement of the crossed-over head (19). For the tops of **B D E F P** and **R,** the latter is more elegant and is therefore to be preferred. In using the cross-over junction for making **D**, the curved second stroke (as with **B**) may quite acceptably in crossing over leave the commencement of the main stem exposed (19), happily manifesting verve and speed. When this top is used, the second stroke may begin just in front of the top of the main stem and may be prolonged outwards and downwards in a curve that transfers to the left corner of the pen. In all such movements it is essential to maintain 'follow through' (see p. 144).

Capital roman **E** is a narrow letter of three horizontal strokes added to the right of a vertical stem in the

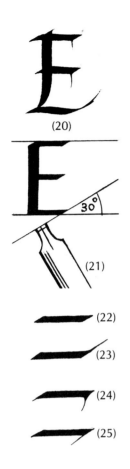

(20)

(21)

(22)

(23)

(24)

(25)

(26)

(27)

rough proportions of two squares high (20). The endings of the top two horizontal strokes should align vertically, but the toe of the lowest one may extend itself a little; partly as a steadying influence; partly for emphasis; and partly as an expression of the high spirits that terminal strokes invite. A working-edge angle of 30° will give for the horizontals a weight of precisely half that of the verticals (21).

The two upper horizontal strokes of this letter require more than just the pen's removal on completion (22); although this can look well if taken up into a short sharp oblique (23). A form of beakhead can be satisfactory (24), and is not difficult to manage. A diagonal may also descend, (25), briefly. Vestigial beginnings to these horizontal strokes are acceptable (20). The beginning of the middle stroke may be covered by the main stem (26), or it may affect a sharp 'touch' (27).

As in the case of other capital letters having vertical main stems – **B D F H I J K L P R T** and **U** – **E**'s main stem need not and perhaps should not be of ramrod stiffness. The human backbone system is not rigid, but curves gracefully and appropriately over its length to stand upright. Provided the notional axis of the main stem is vertical, the letter may gain from a judicious swaying (27). In the same way, the horizontal strokes may indulge in a discreet degree of movement without spoiling the character of this letter.

As may be seen most clearly for **E**, in the most

extreme 'rustic' roman written capitals of the early centuries A.D., the barrel of the pen was held in such a way as to yield hair-line vertical stems, and horizontal ones of the pen's full width. Other, later, bookhands – very well-known insular ones – use working-angles of hardly more than 10° from the vertical. The smaller this angle, of course, the weaker the script. The nearer to the horizontal, the stronger – with strength added, one may say, to elegance. Today's compromise is the very workable pen-angle of 30° from the horizontal (21).

In order to *appear* central, **E**'s middle member is best placed resting *upon* a notional line that is actually central. At true centre it would look depressed (the illusion applies equally to **H**). The horizontal member should not be placed too high, as was frequently done for 'art nouveau' letter **E** (28), and indeed by Renaissance medallists. There are two alternative capital **E**s; one fanciful (29); and one round (30) (which is, in effect, letter C with a horizontal member – see p. 25 and (116)). The choice of form is the scribe's: square **E** and round **E** are accepted as formal, while the two-lobe **E** may lend itself more to italic and to informal use.

Most of what has been said about **E** also applies to **F** (31) – and it is particularly important to note that the horizontal member – see p. 25 and (116)). The the right only, since for some reason it can prove tempting to begin these far to the left and outside the main stem; resulting in uncharacteristic forms (32,

F

(33)

G

(34)

G

(35)

G

(36)

G

(37)

G

(38)

G

(39)

33). However, treating **F** simply as an **E** without its lower member tends to create a visual vacuum to the lower right of the letter. Nothing should be done to extend the foot of the main stem to occupy this space; for the letter will then tend to be read as an **E**. But the second horizontal stroke may in this case be placed at the geometric centre, using the illusion noted for **E** to reduce the vacuum. The subtlety of this expedient will allow it to escape notice in any sequence of capital letters that includes **E** and **F**, even where they are adjacent.

Capital letter **G**, like **D**, possesses great dignity and presence (34). It is one of the wide letters of the roman alphabet. One may regard **G** as **C** with the addition of a half-stem, the form of which is capable of substantially altering its 'facial image'. **G** with a short stem is a weak and feeble letter (35); the more so if there is recession (36). **G** with a long half-stem, on the other hand, is 'aggressive' or 'lantern-jawed' (37); especially if there is projection (38).

 G also differs from **C** in that the termination of the first (downward) stroke is best trailed out more horizontally (34) than in letter **C**; so that the half-stem of **G**, including its small horizontal terminal stroke, ends just below the half-height. In other words, the first stroke should not curve up into the half-stem, forming an unstable letter (39), something as reprehensible as top-heaviness.

(40)

H

(41)

I

(42)

J

(43)

H is another of the wide letters needing generous spatial treatment (40). A rectangle four units wide and five units high will provide acceptable proportions. As in the case of **E** (and for the same reasons), **H**'s horizontal member should rest above a half-height position. And it is again quite acceptable that its sharp beginning and ending project slightly outside the main stems.

With regard to the heads and feet of **H**, simple short cross-strokes are shown; but another treatment of the head-strokes is available. It involves what amounts to two arabic numeral ones linked by a horizontal bar (41). While these tops do come naturally to the pen, I recommend that very short cross-strokes be used for the heads (40) since these are more in keeping with the traditions of both classical and renaissance models.

The stroke that forms the stem of letter **I**, never dotted in capital form, occurs in the alphabet some fourteen times as the main stem or stems of letters, twice in letter **H**, as we have seen (42). **I**'s stem may with advantage possess the animated but upright sway already referred to under **E** (43). Its head is formed by a short horizontal stroke (which on no account should approach the width of the top stroke of capital **T**) and its foot by either a similar short stroke or a diamond-shaped one (neither of which should be prolonged into anything like the lower member of capital letter **L**). A stem-head frequently seen is easily confused with arabic numeral 1 (223),

and is therefore to be avoided. Little elaboration should be attempted with this letter, which for elegance must rely upon simplicity.

(44)

(45)

Letter **J**, like **K**, **U** and **W**, was not used by the Imperial Romans in their alphabet. It is a letter that can tempt the scribe to excess. What sort of head and tail is given to it will depend upon the space available and the mood of the penman. If an initial letter, the head may be extended into the margin. The tail-stroke may end in a flourish (44), or, for decorative purposes, be taken down into the interline space (45). The tail-stroke may also be extended into a hair-line taken beyond the axis by the left corner of the pen.

(46)

(47)

(48)

Letter **K**, as we have just noted, did not feature in the roman alphabet (46). Its main stem is as letter **I** with the addition of a broken pen-stroke. This is made without the pen leaving the writing-surface and in such a way as to ensure that the apex of the stroke does no more than touch, or almost touch, the main stem at a point at, or minutely above, the centre. The stems should not be allowed to merge into each other, or congestion is bound to occur (47). Nor should the tail be used as a kind of crutch to support the upper right-hand member, as is frequently seen (48). The tail, like those of **J L Q R** and **Z**, lends itself to extended flourishing.

Capital letter **L** may be seen as an **I** with the addition

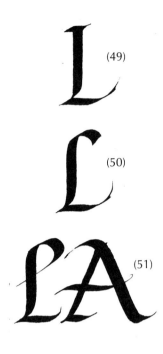

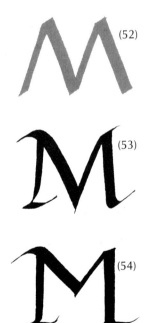

of a horizontal stroke like the lowest member of the letter **E** (49). **L** may be given a variety of heads, the choice depending on what opportunity allows, or on what continuity of style, or spacing suggests. For instance, before capital **A** where a vacuum occurs a beakhead (50) may be suitable. And, while a triangular head to this letter could hardly cause confusion with arabic numeral 1, for reasons of continuity of style one might well opt for the short horizontal stroke as discussed above for **I**, or even the flourish shown here (51).

For reasons already given (under **A**) the first and third strokes of **M** are slimmer than the second and fourth, which are stressed (52). **M** should perhaps be envisaged as a wide **V** propped up on either side by near-vertical stems (53), and not as a mere zigzag or inverted **W** (**M**).

 M is a subtle letter demanding persistent practice to master. In order that the first, near-vertical, stroke does not compete in strength with the second stroke, the pen, in making it, should be turned anticlockwise a few degrees, so that the stroke is made at something like half strength. As in the case of a sharp top to letter **A**, precisely how the junctions of **M**'s inner strokes function is important. In Renaissance times the central junction was frequently positioned at a point only half-way down the internal space (54), creating a vacuum but avoiding the trouble caused between the conjoined stems where they touch the bottom guide-line. This

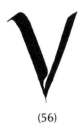

(55)

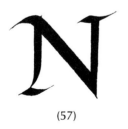

(56)

'trouble' is, of course, the 'blunted' joint that results from a 30° working-angle (52). A sharp ending could be contrived were the pen to come in at 30° from the right (89), but there is no room here for this, even if it were desirable. The correct solution is one of manipulation. Shortly before the heavy second stroke reaches the lower guide-line, the right corner of the pen is twisted anticlockwise off the writing-surface, leaving its left corner to complete the distance (55). In so doing, ink is dragged to a pointed, if ragged, shape, into which the third stroke may aim, merging the two stems (56).

The second stroke of capital **M** may commence as a curved run-in (53), or may be treated with a short head-stroke covering the 'hinge' (55). The junctions of strokes three and four may also be given such a head-stroke to match, or may be contrived in the form of a point as discussed under letter **A**. In fact, all three junctions may be pointed. Such points must project slightly into the interline spaces above and below in order to maintain visual alignment with the other letters in a sequence.

In roman incised lettering one finds that the two vertical side-stems which enclose the dominant diagonal of letter **N** are unstressed, rarely being permitted to compete with it as two full-value stems. One can attain this result by twisting the pen anticlockwise to 60° from the horizontal for its two descents (57). The diagonal itself, however, should be carried out at the working-edge angle of 30°. In

(57)

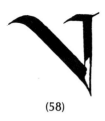

(58)

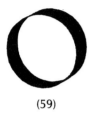

(59)

making this stroke at this working-edge angle, the pen's right corner will need twisting away from the writing-surface as its left corner approaches the stroke's end, leaving a wet inked shape into which the third stroke may be suitably aimed (58).

The outer proportions of letter **O** may be thought of as those of a circle within which run its two curved stems, so that the finished letter seems to be slightly less than circular (59). The pen's working-edge angle of 30° from the horizontal will ensure that the thickest point of its left stem is lower, and that of its right stem is the same distance higher, than centre, as is the case for such curves in letters **B C D G O P Q R** and **S**. Because of this it might be assumed that letter **O** leans over to the left; but, in fact, when well made, its sides being counter-balanced, it is perfectly poised, with no visual tendency to spin either way or to roll off the page.

It needs assiduous practice to achieve **O**s in which the right and left curvatures are balanced. Inspection of the **O**s in a text frequently reveals all left curves to be identical and all right curves to be identical, but rarely lefts to be complementary with rights throughout, something of course to strive for.

Since **O** bulges at the sides, it must be projected very slightly through top and bottom guide-lines to compensate for a visual recession at those points. Otherwise its rounded shape will appear to fall short of alignment with the other letters in a sequence. The same projection must be borne in mind when

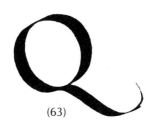

forming the strokes of similarly curved letters.

Letter **P** may be considered either as a **B** with its lower lobe missing or as a small capital **D** with its main stem extended downwards (60). The bottom of the lobe may be strengthened leftwards into the main stem, as in capital **D**, or be left sharply in 'mid-air' without reaching the stem at all, as is the case in many (late) roman inscriptions (61).

 P is related to **B** as **F** is to **E**, since in each a part is 'missing', in the case of **P** the lower lobe of **B**. Like the partial solution to **F**'s problem, the vacuum under **P** may be lessened by a lower ending for the lobe.

 Whatever style of foot is added to the main stem, any temptation to fill the vacant space with it (62) should be resisted.

Letter **Q** is one of the most elegant and distinguished characters of the roman alphabet (63). Its structure is as for letter **O**, with the addition of a swayed tail, which normally enters the interline space. For centuries the tail has attracted the attention of scribes, who have on occasion flourished this pen stroke extravagantly. The alternative treatment of the tail shown here, in which about half of it occupies the inner space, may be used should space below the letter be restricted (64).

 In English **Q** does not occur very frequently as either a capital or a minuscule letter, but where it does appear in a word it is invariably accompanied by a capital or minuscule **u**.

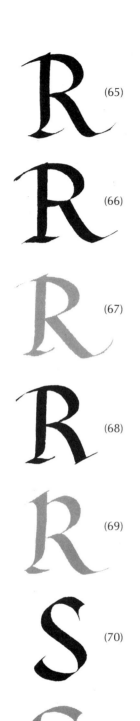

(65)

(66)

(67)

(68)

(69)

(70)

(71)

R is one of the most intriguing and challenging of the capital letters. It is like **P** with a tail-stroke added. Its second stroke, broken like that of **K**, may be completed without removing the pen from the writing-surface, darting in towards the main stem and rebounding after scarcely touching it, to end diagonally in a lively swayed stroke (65). Renaissance scribes were given to propping this letter up with its own tail, placing it under the bow (66). A structurally weak treatment sometimes seen simply carries the second stroke on from where the bow touches the stem but without first bouncing away, resulting in a lack of proper support and a restricted appearance below (67).

Whatever is done with the tail of letter **R**, which like **K**'s tail is on occasion flourished into the space below the line, its notional axis should run through the top of the main stem (68), something which the axis of the tail in the last example could never manage.

On occasion a treatment is seen in which the top of **R**'s main stem is formed on the lines of an arabic 1 with a triangular head and the lobe tucked inside it (69), not perhaps the most valid way of constructing this letter, and reminiscent rather of one of the two ways of making minuscule letter **k** (155).

Like **M**, letter **S** has much more to it than meets the eye. Ideally, it is a diagonal with curved extensions (70) rather than merely a cottage loaf of two circles touching, one above the other (71). However, like a

BASIC CAPITALS 18

cottage loaf, the upper part of this letter should be the smaller (see **B E H** and **X**). When such divisions of internal space appear to be equal, turn the letter upside down and look again; for it is a well-known optical illusion that truly vertical centres appear to sink or, to put it another way, truly equal areas when placed together vertically seem top heavy. The solution is to increase the lower area and reduce the upper one by raising the dividing member very slightly to a point where things seem visually balanced, something which the penman takes in his stride.

S needs further consideration, however. For if the ends of its upper and lower members align vertically with bottom right and top left curves respectively, the letter will tend to appear to be falling backwards. The solution is to align things vertically on the right, but to project the lower limb slightly beyond the point of vertical alignment on the left. In this way, **S** will seem to adopt a more forward-looking and progressive stance (70).

The curved top stroke of this letter terminates at its heaviest moment, and ends in the manner already demonstrated for **C** and **G**. However, since such a shape cannot be arrived at in reverse, the third and lowest member should either commence immediately, the scribe simply putting the pen down onto the writing-surface, or, if preferred, begin in the interior of the lower area of the letter (72).

(72)

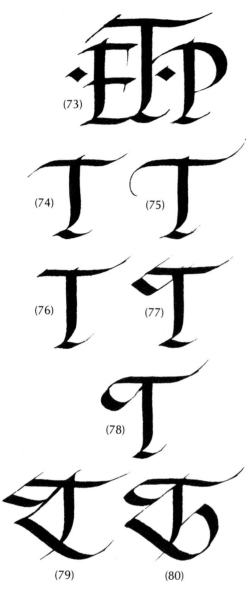

(73)

(74) (75)

(76) (77)

(78)

(79) (80)

On page 3, **T** was classed, by means of parentheses, as being both a narrow and a wide letter. For **T** may be given either a short top stroke or a long one – not so short that the letter begins to look like **I**, nor so long as to cause spacing difficulties. Sometimes, as the roman letter-cutters demonstrated, the stem of **T** projected upwards so that the cross-stroke may make use of interline space (73).

T's top stroke, written at a working-edge angle of 30° from the horizontal, will be half the weight of the main stem. Its ending should be made crisply, upwards and outwards, as the pen lifts from the writing-surface. Its beginning may be accomplished either by means of a hair-line that curves upwards and inwards from the left (74) (something at times taken further down with the left corner of the pen (75)) or simply by putting down the whole working-edge and immediately moving the pen to the right (76).

Vestigial beginnings to the main stem may be allowed to remain visible above the cross-stroke, as in letters **B D E F M N P** and **R**. Additional pen strokes for the top of **T** as an initial letter are available (77, 78). In vernacular manuscripts of the fourteenth and fifteenth centuries we find (79), even (80).

Capital letter **U** did not exist as such for the romans. It is really a round-based **V,** and its present structure evolved from **V** to (81), and finally to (82).

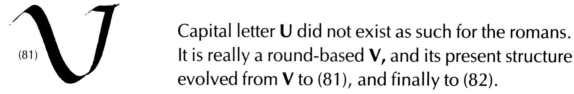

(81)

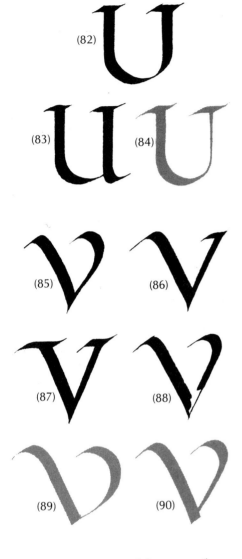

In the avoidance of any doubts concerning stability, round-based **U** simply put its foot down (83). Like the illusions of leaning backwards, and of top-heaviness, instability has always been anathema to some. Nevertheless, a foot is not always used. At times, designers of letters and of type faces have mistakenly slimmed **U**'s second stem virtually to nothing (84), remembering its origin as **V** but forgetting that when round-based the stems proceed in the same direction (they are both vertical) and should therefore be of the same weight – an orthodoxy the pen automatically follows.

The junctions of the stems in all three versions of capital letter **V** (85, 86, 87) involve the sleight of hand discussed for **M** (88). This manoeuvre is required; for otherwise, either a silly and unacceptable shape that has an axis twisted over to the right suggests itself (89), or an unwanted triangular portion of the end of the left-hand stem (placed by the 30° working-edge angle) will protrude beyond the right-hand stem (90).

As a capital letter, **W** is additional to the Roman alphabet and now consists of two **V**s joined together. In early medieval times, two **V**s were used separately, in sequence (91).

Double-**U**, or as the French more correctly name it, double-**V**, has pointed junctions below, which like those of **M** and **V** must be sharp, and a choice of tops. The tops may be either all curved (92); partly

(93)

(94)

(95)

curved and partly straight (93); or all straight (94). Where the two **V**s join it is best to overlap their stem-ends so that they share the join precisely. That is, the two **V**s should not be arranged in such a way that the first overlaps the second (95), or vice versa (96), as is sometimes done. If there is a lack of space, it may be better to interlace the two **V**s, crossing the stems as for letter **X**. A balanced distribution of background areas within the letter is thereby produced (97) and congestion above or below avoided (98), (99). If they are interlaced, the two **V**s may be made marginally wider, as in the middle of **M**. All such treatments (see, for example, **F, G** and **Z**) must be both reasonable and discreet enough to pass unnoticed.

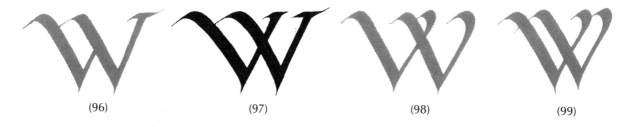

(96) (97) (98) (99)

(100)

For the pen, the form of **X** is most naturally that of a narrow letter. The diagonal leading in from the left should end outwards and upwards, and be crossed with something like a narrow leaning letter **Z** the top and tail of which each consists of a short horizontal stroke (100). Like **E H** and **S, X** must avoid top-heaviness. A crossing of stems slightly above true centre will look visually central.

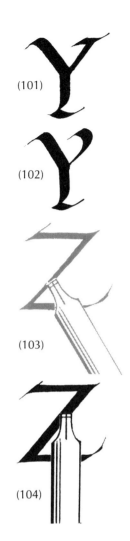

(101)

(102)

(103)

(104)

Letter **Y** may be thought of as a short, wide letter **V** carried upon the lower half of a letter **I** (101, 102). Like **T**, it has a spatial vacuum on either side of its half-stem: attention will be given to the management of this when the matter of spacing is discussed in Part II (see pp. 90).

Calligraphically, **Z** is normally a cheat, since an inherent but undesirable thinness of the main diagonal (103) is avoided – and one of suitable strength provided – by turning the pen's working-edge to the horizontal (104). **Z**'s top and bottom strokes are performed with the pen's working-edge at the usual 30° from the horizontal.

The ampersand (105) – 'and per se' (by itself) – evolved from Latin **ET** (106): a rounded version followed (107); then (108), which amalgamated the two letters; then (109); and finally (110). When turned anticlockwise some 45°, (111) is obtained, which many use in their handwriting, simplified still further into a scribble (112).

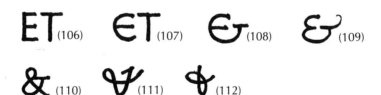

ET (106) ET (107) & (108) & (109)

& (110) & (111) & (112)

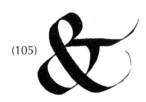

(105)

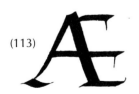

(113)

With regard to capital diphthongs **Æ** and **Œ**, whereas in later roman stone inscriptions **Æ** appears with **E** leaning backwards into an upright **A** (113), in

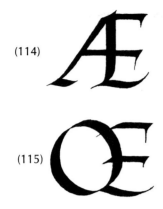

(114)

(115)

current usage **E** is given priority of pose (114). In capital **Œ**, **E** is also given priority of pose nowadays (115), but in this case the penman may well defer to scribal inclinations and reach an alternative solution (115).

Uncial

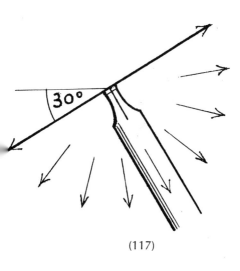

Uncial (see Plate 1), the third main book script in European use, was employed from possibly the third to certainly the eighth century A.D. It developed as an adaptation of the roman alphabet to suit better the needs of the penman, using curved strokes that were, for the pen, more facile and economic than the traditional straight ones. The greater economy in strokes has led to confusion among non-practitioners. Uncial **E** (116), for example, has been wrongly described as a letter of two strokes, in contrast with **E** of four. In fact, round **E** requires three strokes to complete it, not two: the back (and lower) curve; the head-stroke; and the cross-bar. (Some palaeographers have claimed an even greater economy for minuscule **e**; suggesting that it was done in a single stroke. But in formal bookwork the pen is moved only *towards* one and never pushed spatteringly upwards, digging into the grain of the writing-surface (117). Formal minuscule **e** in fact comprises two curved strokes.)

Even though manuscript books nowadays are best done in the minuscules that we are accustomed to read, the uncial book script is as valid today as any modern descendant of the square capitals. The following modern example is a perfectly serviceable working alphabet (118):

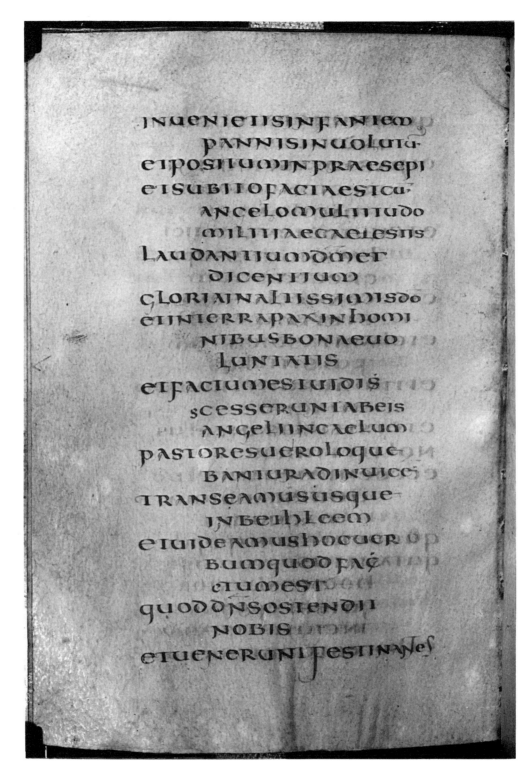

Plate 1: Latin Gospels (St. Jerome Version) perhaps from N. Italy, VI or VII century. British Library Harley, MS 1775. The pen is used here with its edge at work horizontally.

A B C D E

F G h I J K

L M N O P

Q R S T U

V W W X

Y & Z (118)

UNCIAL 27

Basic minuscules

By the fifth century A.D. the uncial style had
engendered what is now termed 'half-uncial', and
throughout Western Europe was developing in a
variety of ways into true minuscule book scripts. Of
these, it was the Carolingian script – to which Italian
Renaissance scribes, and later the early printers,
looked back, to the disfavour of blackletter – that
underwent (in its Winchester version) retrospection
and revival at the turn of this century. This revival,
by the great scribe Edward Johnston, now after
three-quarters of a century demands, and will here
receive, reaffirmation.

The following penmade minuscule characters
(119) have a weight or minim height of four

(119)

A modern basic script
derived from tenth and
eleventh century English
Caroline minuscules—
updated for current use

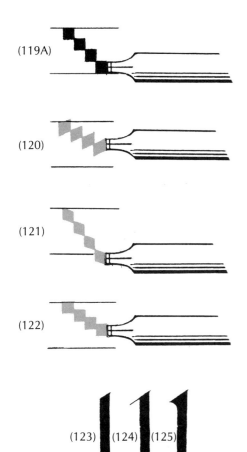

(119A)

(120)

(121)

(122)

(123) (124) (125)

(42)

(126) (127)

nibwidths. This might be thought of as a bold weight and five nibwidths as a light one. The pen's nibwidths must be added together accurately (119A), without falsifying values either by an ascent (120) or a descent (121), or by overlapping them into a shorter measure (122).

Secondly, there is the question of the form best taken by ascender and minim tops. There are four alternatives. The most straightforward is made by simply putting the pen down on the writing-surface and immediately beginning the descent of the stem (123). But this seems somehow dull and unenterprising. To lead in from the left along the pen's edge to the point at which it begins its descent is quite logical, yet still insufficient (124). However, by adding a curved bracket in the angle so formed a satisfying and adequate head may be provided for ascenders **b d h k** and **l** (125). The other alternative is a short cross-stroke. However, while it is better suited for alignment with the tops of other minuscule ascenders (and, indeed, with those of the associated capital letters (42)) this short-stroked head has never found as much favour as the bracketed head just described.

Although the addition of a bracket rather than the use of a curved run-in is recommended for the tops of ascenders – since accuracy is more difficult to achieve in the curved aim for a descent (126) than in a straight slide-in (127) – for the tops of minims, it may well be equally valid penmanship to use this (more difficult) curved run-in.

Finally, there is the question of ligatures. A distinction should be made between stereotyped instances of ligatures, in which a stroke-ending or flourish projects into a following stroke, and those that are what Sir Hilary Jenkinson in *The Later Court Hands in England* termed the 'currency' of script; that is, the tie-strokes of a current or running hand.

fi, fl, ff, ffl, ffi

(128)

Ligatures are treated in a somewhat circumscribed manner by printers: **fi, fl, ff, ffl, ffi** (128). The penman interprets the term 'ligature' with a far wider scope, adding, for instance, (129) and many more. He links letters unhesitatingly, as part of the penflow system, in *ad hoc* solutions and with an infinitely adaptable approach.

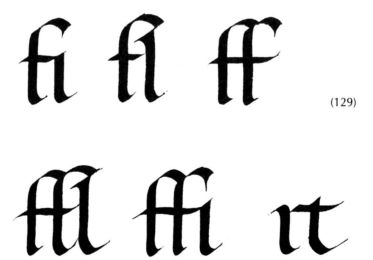

(129)

The descent of minuscules from capital letter form may be readily appreciated (130). The vacuum

A ᴧ ɑ a B b C c Ɒ Ꝺ ꝺ d

E Є e F F G ɢ Ꞩ Ᵹ

G G g H h I i J j K k k

(130) L l M ꟽ m N Ꝺ n

O o P p Q Q q R R ꝛ r r

S Ʃ ſ ſ s T Ꞇ t V V U u

V v VV W w X x Y y Z z

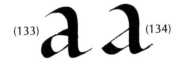

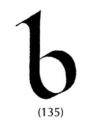

(131) (132) (133) (134) (135)

above the lobe of minuscule **a** (131) is something to be reckoned with in spacing (see p. 79). It may be lessened to some extent by pushing a hair-line stroke made with the left corner of the pen downwards and back into the opening (132). The optional small triangular touch into the main stem from the lobe yields additional sparkle (133). An alternative, sharpened, form of lobe is also available (134).

The first of the two available **b**s (135) has a flowing, rounded base, in tune with other letters in the minuscule alphabet – **c e o** and **s**, for instance. The

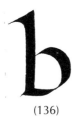

(136)

(137)

base of the other is formed by a separate, short, horizontal stroke. From this structural difference a significant gain in stability results. The first is unstable – it is a potential 'rocker'. The second (136) is more soundly based: its repetition will lend that much more steadiness and tranquillity to any area of text making use of it.

There is a temptation when forming **b**, as there is with **d p** and **q**, to coalesce the vertical stroke with one of the strokes that form the sides of **o** (in the case of **b**, the left-hand side) (137). This temptation is to be resisted. The Book of Kells and the Lindisfarne Gospels are exceptional among medieval manuscripts in tending to use this formation. Edward Johnston experimented with it in 1930 – in a formal italic hand – but not thereafter. The paucity of historical examples argues against it. (The coalescence or mutual biting of stems in blackletter is, as we shall see, another matter.)

Minuscule **c** comprises two strokes, formally identical with those of capital **C**, and the ending of its second stroke calls for similar expertise (138).

(138)

Letter **d** might be described as simply letter **c** with an ascending stem added (139). The top of the ascender is as for **b**, and its foot turns towards the following letter as the pen leaves the writing-surface. The small stroke at the top of the lobe (not unlike the head of letter **c**) does much to strengthen the form and enhance the calligraphic effect.

(139)

(140) (141)

(142) (143)

(144) (145)

Minuscule **e** is one of the more difficult letters to perform convincingly. It comprises the stroke that forms the left side of minuscule **o** with an enclosure, which contains slightly less than half of the space confined by the first stroke, added at the top (140). These proportions require care: if the enclosure is too small, the letter risks leaning backwards (141); and if too large, it may well appear top heavy (142). The angular venetian **e** offers an alternative (143).

Minuscule **f** combines an ascending stem with a curved head and modest upcurving foot, drawn from the stem (144). The stem is crossed by a horizontal stroke of the kind to be found in capital letter **F**, in this case reaching up to touch but to go no higher than the upper guide-line. This stroke commences just outside of the left edge of the main stem, forming a modest triangle, and moves through it to the right. An alternative foot to this letter is diamond shaped (venetian), as shown (145). The choice will depend upon consistency with other letters in the script being used.

Minuscule **g** is a most characteristic letter and a most satisfying one to perform; but its proportions and structure are complex and require a deal of practice to perfect. The upper, and lesser, bow descends only some two thirds to three quarters of the way towards the lower guide-line. This both allows for the neck, and enables the tail to start at the lower guide-line and so to occupy as little as possible of

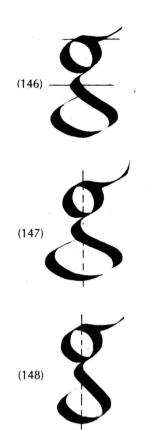

(146)

(147)

(148)

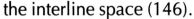
the interline space (146).

Two further points should be made. First, the tail must be in precise visual balance. To achieve this it should share an axis with the upper bow. This is secured by matching the left-hand counterpart to the right-hand stroke. For the sake of an upright letter, whether the first stroke of the tail is well away from the axis (147) or close to it (148), the counterparts should be in visual balance. Secondly, the evolution of any letter must be borne in mind when deciding on its exact form. In this case (130), should the small flourish at the top of minuscule **g** – the remains of the head of capital **G** – be preserved? Medieval writing generally acknowledges that it should: but Johnston's foundational hand in *A Book of Sample Scripts* (as well as the later notes on formal penmanship) chose, with few exceptions, to omit this stroke as superfluous. The penman must decide; but the author, finding this termination to the letter both reasonable and attractive, considers its preservation worthwhile.

Minuscule letters **h** (149, 150) **m n u** and **i** are deceptively straightforward. Their very simplicity demands an extra fine handling since the placement of their stems contributes so much to the rhythmic flow of a script. The head of the main stem of **h** is as for the other ascender stems.

What can be said about such an elementary stroke

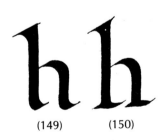

(149) (150)

(151) (152)

as the minim of minuscule **i** (151, 152)? Calculations show that approximately five per cent of an English text comprises this letter, and that other such vertical stems (with various endings) occur in over half the minuscule alphabet.

Although it is still customary to dot one's **i**s, there is now no reason to do so beyond habit. The retention of dots in print during the fifteenth century had little to do with need. In the twelfth century, slanting ticks were placed over two letter **i**s when they were used together to distinguish them from the letter **u**. But in basic scripts of today the differences between characters are so marked that both ticks and dots may be entirely done away with – to the greater tranquillity and dignity of the text (119).

(153)

Letter **j** (153), like **u**, **w** and **k**, did not feature in the roman alphabet of capital letters. The descendant form, with its curved ending to the left, provides the scribe with another opportunity to transfer the action to the corner of the pen for an enjoyably sharp finish to the stroke. D. B. Updike in his book *Printing Types: Their History, Forms, and Use* (2nd. ed. 1937) discusses briefly the early interchangeability of **j** with **i**, and the evolution of their distinction as consonant and vowel respectively (likewise between **v** and **u**).

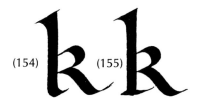

(154) (155)

K's capital form has changed very little for minuscule use (154, 155). Minuscule **k** may be written without closing the top of the lobe, which

(156)

should not be too large or the letter will tend to look top-heavy. As we have noticed for capitals **K** and **R**, where the broken stroke changes direction on its way down, the point of this angle should do no more than touch the stem, if that. Subject to available space, its tail may be flourished (156) if desired.

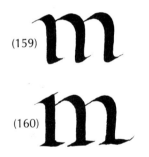

(157) (158)

The foot of minuscule **l**, in acknowledgement of the letter's capital origin, should be extended slightly more than the normal ending to a written stem (157). Some scribes use a short 'venetian' stroke (158); but for basic minuscule the upcurving tail, drawn from the stem, should be sufficient.

(159)

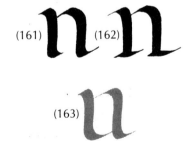

(160)

As with the tops of minims generally, it may well be better penmanship to flow from the left into the top of **m**'s first stroke rather than to contrive an introductory bracket. The feet of the stems of **m** may either end calligraphically curled up – modern basic (159) – or rest soberly, flat on the bottom guide-line – small roman (160). The stemmed letters **m n** and **i** are a steadying influence on a written text: this is patently so in Latin, which abounds in them.

(161) (162)

(163)

As for **m**, so for **n** (161, 162). Further, it is important that **m** and **n** be clearly closed at the top and open below, since the reverse can lead to confusion with **u** (177). Weak arches and slurred feet create this difficulty (163).

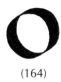

(164)

Minuscule **o** is one of the key letters of a basic script (164); for **b c d e g p** and **q** make use of stems similarly curved. Mastery in this respect will therefore greatly enhance the overall appearance of a written text. As in capital **O**, its exterior may be taken as circular, with the curved stems added inwards to give a somewhat narrower than circular appearance. The minuscule form of **o** also suffers a notional recession – upwards and downwards. Compensation by a slight projection through the upper and lower guide-lines will again effect alignment with preceding and subsequent letters.

There is little excuse for failing to commence **o**'s two curved strokes from the same point; but to match them exactly is by no means easy. Left-hand strokes may well be similar throughout an alphabet, and right-hand strokes may also match; but it takes skill and practice to make strokes which mirror precisely their shape on either side of this letter's tilted axis – something well worth striving for.

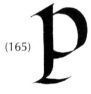

(165)

(166)

Although the stroke that forms the right-hand side of **o** is evident as the lobe of letter **p** (165), **p** is not merely an **o**-form with a vertical descender running through its left-hand stroke (166): The stem is touched at two points. The lower touch may be with the short triangular stroke advocated for minuscule letter **b** (136). The descender of minuscule **p** may either have a diamond-shaped, 'small roman' foot (165), or simply end as a hair-line (166).

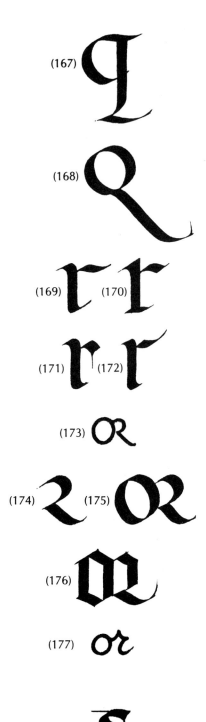

Minuscule **q** (167) is a kind of reflection of letter **p**, with its tail perhaps marginally longer, in memory of its ancestry. In modern minuscule script, this letter is sometimes found in parental form, comprising a minuscule **o** with an underflourished tail (168).

Minuscule **r** (169, 170) had a strikingly clear evolution from its capital form (130). Except at the end of a word, the top stroke of **r** – the evolutionary remains of the lobe and tail of its capital form –, if drawn out too far, will cause a vacuum below (278). It may consist of either a diamond-shaped pen stroke, with perhaps a vertical hair-line finish (171), or a short horizontal stroke (172) (see p. 88).

Recalling capital form, on occasions where space was restricted, the roman letter-cutter utilised the second curved stem of **O** as the main stem of **R** (173), and the medieval scribe followed suit (174, 175), even in blackletter (176). Centuries later the notion was picked up again in the 'commercial copperplate' and 'civil service' hands (177), and even survives in personal handwriting today.

Comments made under capital **S** are valid for minuscule **s** also. It is a letter which is in use very frequently in English and repays the greatest care. The reduction of internal space in minuscule **s** at a nibwidth height of less than four will produce dark-looking letters – ones that will stand out in a textual area (178). As a result, these are often found

(179)

trespassing slightly into the interline spaces above and below (179). Like capital **S**, minuscule **s** is formed by a diagonal with subtly curved extensions (which contain more space below than above) rather than one of 'cottage loaf' shape. And again like the capital form its middle must be sufficiently above centre to appear central. Its head ends as for **c** and the forms its terminal stroke may take are the same as those discussed for the capital form.

(180)

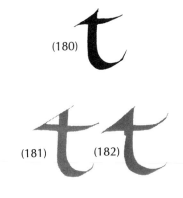

(181) (182)

The curved foot of letter **t** may, perhaps should, extend itself just a little (180), rather as letter **l** does; but in this case to match the short horizontal head-stroke, which is placed underneath the upper guide-line. It is important to cross minuscule **t**s properly: the triangular area of background contained by the head-stroke and the top of the shaft on the left-hand side should be kept to a minimum. It should not be so large that it begs a filling with ink (181). Filled with ink it would be clumsy and much too heavy (182).

(183) (184)

It was the uncial and half uncial penmen who completed the process, first evident in both square and rustic capitals, of rounding the sharp point of letter **V** into a form not dissimilar to that of the minuscule character (130, 183, 184). Subsequently vowel **u** and consonant **v** co-existed.

(185) (186)

Minuscule **v** is capable of a variety of treatment in its tops (185, 186), of which the first shown here is the

most calligraphic. The second requires for the pointed junction of its stems the sleight of hand described and demonstrated for capital **V** (88).

(187)

(188)

Like **v**, **w** is open to variety in its tops (187, 188); but four straightforward strokes, the last of which is curved, is the treatment that seems most valid as penmanship. Care must be taken that the two **v**s are complete in themselves. And their junction should be a truly shared one: neither **v** should be outraged by overlapping by the other (see 95, 96). Interlacing is a consideration for capital **W**, where desired (97); but hardly so in minuscule form. It is legitimate to inscribe each of the two **v**s somewhat more narrowly than a **v** used by itself, although not noticeably so.

(189)

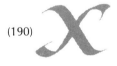
(311)

(190)

Minuscule **x** poses one or two problems. The pen, being versatile, could give an *ad hoc* answer for each situation. However, an alphabet suggests consistency. There is no problem with the main oblique stroke (it comes in naturally in a south-easterly direction); but what follows is more debatable. The first example here (189), while thoroughly calligraphic and flowing, is visually restless, and bears an uncomfortable resemblance to a disjointed dipthong **æ** (311). The second takes account of the vacuum on each side due to receding letter form, but in doing so has become fussy (190). The third example is perhaps least considerate of recession; but it is crisp and dignified, with a more

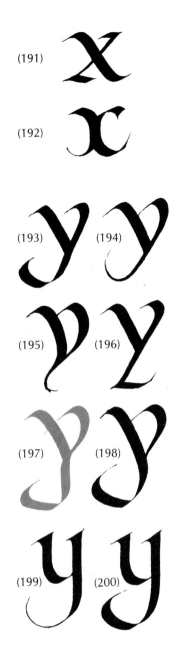

(191)

(192)

(193) (194)

(195) (196)

(197) (198)

(199) (200)

(201)

clearly defined top and bottom (191). A second though perhaps less legible choice could be of two biting curved stems (192).

Minuscule **y** occurs frequently in English, not least in the termination of adverbs. Its tail may take on a number of forms, of which the main ones are shown here. The first example is the one usually adopted for a basic script (193). The second, which has the merit of not being lopsided, is a version for use on suitable occasions (194). The third is a useful and lively variant in basic script, formal italic and blackletter (195). The fourth is a staid form to accompany the small roman (venetian) mode (196). The fifth is perhaps a reasonable attempt to centralize the tail, but it ends somewhat disastrously in a broken back (197). The sixth attempts to enable the tail of **y** to avoid forming diagonal stress notes throughout an area of text (198). Its top must be open, or italic **g** may be evoked. There is a possible alternative form of minuscule **y**, not so characteristic of the letter (199, 200). But in spite of the regular beat of its stems, it cannot wholeheartedly be accepted as a **y**. Even blackletter is happier when using obliques.

Minuscule **z** (201), as in the capital form, requires an additional 30° clockwise twist of the pen to provide weight for its diagonal stroke, which would otherwise be a weak, thin line (103). The top and bottom strokes, running inside the guide-lines,

(202)

(203)

begin and end respectively at the pen's dictation. So that the letter may be upright, care should be taken that these are of a length to match the width of the diagonal – that is, not (202) or (203).

Blackletter

The Concise Oxford Dictionary describes blackletter (under 'Printing') as 'now occas. used for ornamental purposes', and almost without exception the books which touch on the style treat it as an anachronism happily done away with at the Renaissance in favour of the rounded classical modes now generalized as roman.

How Edward Johnston regarded blackletter as a script for children may be seen in his Notes (204, 205), where the derivation of a modern blackletter from a heavy italic as well as from the Carolingian (Winchester) script is illustrated. He takes pleasure and some amusement in the stimulus of blackletter with its 'very handsome' possibilities and, by relinquishing one or two characteristic features, finds the style both legible and legitimate. The penmanship of the great twelfth-century bibles springs immediately to mind, their transitional hands looking not at all unlike the alphabet on page 10 of Johnston's Notes – the first seeking after angularity, the second wishing to avoid it.

However, from the scholar-scribes of the turn of this century blackletter script received apologetic or guarded mention. Hewitt refers to blackletter as 'almost unintelligible and certainly irrecoverable'. Fairbank's calligraphic interests lay mainly

abcdefghi or bd h

The Question of "Black-letter" I do not Specially
recommend this, but it is amusing & may be made
v. handsome. It is quite legible & legitimate if
some of the distinction between curves & straights
be preserved (as in the italic above) and if the ends
of the strokes incline to "hooks" rather than to "diamonds"

{ it may be made dry from a heavy italic written upright
{ & shorter & with external angles permitted (in & ʃ is made with left
{ thus — (the hook (the point of pen)

abcdefghh or bdh

observe that the difference between ——————

(204)

bdh *derived from* bdh

and bdh *which tends to illegibility because of the complete loss of the curves*

(*I do not think the bent head ⌐ suits this "black-letter". The heads are properly squared or fishtailed, but this is rather difficult & involves changing the direction of the pen — wh. is a doubtful course, at least for children*)

bh *or* hb

possibly this compromise would be best for beginners

Fishtail heads made without changing pen's ✗ direction or

The alphabet would then be something like this —

xyz. abcdefgh
ijklmnopqrstuv

(205)

elsewhere. But blackletter should not be ignored. William Morris's Troy type face for the Kelmscott Press (206), directly inspired by his unbounded

Of the Lady and Messire Thibault nephew, son to the Soudan of Humarie, and the daughter of my lord Raoul, for no heir had he save that daughter. William wedded the damsel, and the wedding was done much richly, and thereafter was the said William lord of Preaux.

LONG time thence was the land in peace and without war: and Messire Thibault was with the Lady, and had of her sithence two man-children, who thereafter were worthies & of great lordship. The son of the Count of Ponthieu, of whom we have told so much good, died but a little thereafter, whereof was made great dole throughout all the land. The Count of St. Pol lived yet, and now were the

124

(206)

admiration for the style, attempted to make blackletter legible and to 'redeem its Gothic character from the charge of unreadableness commonly brought against it'. Whilst it yet remains

as Dreyfus has said 'a great achievement and his most important contribution to letter design', Morris succeeded in redeeming it from this charge only by injecting strong if haphazard elements of roman form into his blackletter, so that it is neither the one nor the other. While scribes will admire Morris's great adventure into print, they will find in his Troy design many inconsistencies of angle, weight, stress, curvature and spacing: transcription of this type face into penmanship is a sobering experience!

The blackletter script, which for the penman retains immense authority, and which provides a rich pattern, and an opportunity for refinement, has for too long been neglected as a manuscript hand for situations where the beauty of a text may be savoured as well as its message (207).

(207) surely this is scarcely less readable than a condensed roman minuscule

Palaeographers distinguish between several varieties of manuscript blackletter, of which at least three should concern today's scribes. First, there is the script named 'Textus Quadratus' (208). This was done with the pen's working-edge at from 40 to 45° from the horizontal, and its shoulders and feet were diamond shaped. It is the style most readily called to mind by the name 'blackletter', and was widely employed as a book script in Europe during the fourteenth and fifteenth centuries.

a b c d d d

e f g h h i j

k l m n o

p p q r s s

t u v v w w

x y z z

(208)

Secondly, there is Textus Precissus (209), in which, although its angular shoulders were arrived at in the same way as for Quadratus, the feet of certain minims were squared off, giving a marked stability to the page. To the name 'Precissus' therefore, were added the further words 'Sine Pedibus' (without feet).

(209) **anima mea domino**

Thirdly, there is the softened blackletter named 'Rotunda' (210). This emerged in the fourteenth century in northern Italy, and was taken into use by other European countries, mainly for liturgical and legal works. In Rotunda the angular shoulders of Precissus became arched, but feet retained the squared look. In examining the large choir-books of the period inscribed in the Rotunda style, a magnifying glass will confirm that its squared stem-ends were formed with the acute-angled left point of

a b c o d e f g h i j k l
m n o p q r z s t u w
(210) v x y z

A B C D E F G H J

K L M N O P Q R

S T U V W X Y Z

(210)

A few lines of English in Rotunda style. We have the option to disuse long s which is a hindrance to present day readers.

(211)

1

(210A)

the pen, using the still-wet ink of the stem (210A). (One recalls that upon a sloping board a little ink will fall to the bottom of the letter stems, and that this will provide for further immediate use.) Although in recent times the Rotunda style has been dismissed, like blackletter, as an anachronism, I believe that an updated Rotunda script could well find a place within the modern repertoire (211).

Let us examine the structure of Quadratus and without losing sight of its Roman origins describe a usable form. Its blackness derives from the weight of its stems and their closeness together – perhaps four nibwidths high with something like equidistant stems and equal spaces, as shown here (207). The working-angle of the pen's edge may with advantage be increased from 30° to 40° or more from the horizontal. The liveliness of the alphabet derives from a slight incurvature of each stroke and an enhancement of corners, which the pen can contrive by slipping back fractionally before changing direction into the next stroke. Ascenders (to **b d h k** and **l**) and descenders (to **p** and **q**) end simply, with the appropriate corner of the pen dragging the still-wet ink into a complementary serif.

Blackletter in action is a speedily executed drill based upon a three-stroke minim, with variants.

With regard to the capital letters that should accompany this script, we should look again at English fourteenth-century manuscripts, semiformal and vernacular (for example, the Chaucer BL Harley

MS. 7334), and, acknowledging the past, but deferring to the present, modify such capitals to suit modern needs. An alternative approach could well be the reconversion into penmanship of the splendid capital letters used with blackletter texts by certain of the early printers. For example, those in the style of the leading Parisian publisher Antoine Vérard offer most worthy models for the modern scribe (212).

What today might be the purpose of a blackletter script? The answer must lie in its richness of pattern (207): it may serve as an eyecatcher; or it may be used contrapunctally along with other, smoother, less extrovert styles. But could there be today alternative forms of blackletter to those of the fourteenth and fifteenth centuries? An example by the author is offered in Plate 2.

A modern version of blackletter might use a rectangular structure instead of the traditional

$$\frac{2\pi i}{h}\left[\frac{w+ev}{c}+m_0c\right]\Psi_1 - \left(\frac{\partial}{\partial x}+i\frac{\partial}{\partial y}\right)\Psi_4 - \frac{\partial}{\partial z}\Psi_3 = 0$$

$$\frac{2\pi i}{h}\left[\frac{w+ev}{c}+m_0c\right]\Psi_2 - \left(\frac{\partial}{\partial x}-i\frac{\partial}{\partial y}\right)\Psi_3 + \frac{\partial}{\partial z}\Psi_4 = 0$$

$$\frac{2\pi i}{h}\left[\frac{w+ev}{c}+m_0c\right]\Psi_3 - \left(\frac{\partial}{\partial x}+i\frac{\partial}{\partial y}\right)\Psi_2 - \frac{\partial}{\partial z}\Psi_1 = 0$$

$$\frac{2\pi i}{h}\left[\frac{w+ev}{c}+m_0c\right]\Psi_4 - \left(\frac{\partial}{\partial x}+i\frac{\partial}{\partial y}\right)\Psi_1 + \frac{\partial}{\partial z}\Psi_2 = 0$$

UHLENBECK·ET·GOUDSMIT

Pour expliquer diverses anomalies ont supposé que l'électron était doué d'un spin c'est-à-dire d'un moment de rotation propre

Dirac a écrit des équations de Mécanique Ondulatoire qui tiennent compte de ce spin

From le Palais de Decouvertes, Paris — compte de ce spin — Transcribed by William Gardner, 1965.

Plate 2: Uhlenbeck & Goudsmit, and Dirac,
on the supposed spin of an electron. (Formula from le Palais de Découvertes, Paris) – the laid Papiers Canson are respectively from the top – Burgundy (503), Ivy (448), Violet (507), Steel Grey (431), Moonstone (426), Felt Grey (429), Sky Blue (354), Violet (507), and Ivy (448). The two names at the top are in gold Versals, while the lines of experimental modern blackletter are inscribed in white metal. A white painted wooden square section frame has inside dimensions of 45 cms wide x 30 cms high. William Gardner, 1965.

hexagonal one (although **X** and **Z** might resist the change). Such a version would neither depart far enough from tradition to lose the character of a blackletter nor become a pastiche. It would be felt to be readable. In addition, the outrage of a matching blackletter italic has been envisaged (Plate 3).

Plate 3: "The Structure of Cellulose."
Within a diagrammatic border of its crystallite chains. The laid Papiers Canson are from the top respectively – Dark Blue (500), Steel Grey (431), Moonstone (426), Felt Grey (429), and Ivy (448), repeated in reverse order to the bottom. The square section frame is painted 'putty white', and measures inside 68 cms wide x 38 cms high. Modern 'blackletter-Italic'. William Gardner, 1965.

Formal italic

This style of calligraphy, above all, is the one today in which the professional calligrapher may indulge his facility and challenge his skill. It combines discipline with verve, and licenses adventure – as the upright walking pace of a basic minuscule script leans forward to break into a rhythmical trot, the pen feels the bit between its teeth and is given to doing things with an air. However, basic minuscule script cannot become formal italic merely by slanting its stems, any more than formal italic can become a minuscule script by proceeding upright. It is the alphabet with its variant letters – *a f* and *g* – as much as the stem-slant and letter-flow that makes formal italic what it is: an eminently suitable style for many purposes, not least poetry.

Formal italic is perhaps best written with a stem-slant of between 10° and 15° from the vertical, and – as for basic minuscule script and for the reasons discussed on p. 57 – with the working-edge of the pen maintained at 30° from the horizontal. A stem-slant of less than 5° from the vertical would not suffice to confirm its italic character, while one of 20° or more would jostle the letters, running them off their feet. The addition of a stem-slant of 10° will effectively increase the working-edge angle to one of 40°. Some modern practitioners of italic

"The Passionate Shepherd to his Love."
Verse by *Christopher Marlowe.* A hand coloured lino cut printed upon de Wint paper after a design for embroidery by John Warner C. 1767. A starry sky is spangled with impressions in gold foil from heated type-metal asterisks (Monotype) of two kinds – reflected in the pond below. Sepia calligraphy is in a condensed Italic hand upon Papier Canson Pearl (343). The whole surrounded by a border of gold fleurons (Monotype B.228, 48 pt. and 255, 36 pt.) impressed upon Papier Canson Slate (345), within a moulded frame of limed oak, inside dimensions 50 cms wide x 63 cms high. William Gardner, undated but c. 1955.

(213)

recommend twisting the pen's working-edge to 45° from the horizontal, making – with a modest 10° slant – 55°. Such an angle, however, will visibly over-stress the shoulders and feet of minims and starve the stems. The so-called 'broken' Lombardic scripts of the eleventh century unwittingly exemplify this fault (213).

The following – which admits the existence of some alternative letter forms – may serve as a modern formal italic script (214): In spite of their consistent stem-slant we cannot unreservedly accept (215), nor the compromise (216). As we have seen,

a b c d d e f f g g h i

j k l l m n o p p q r r

s t u v w x y y y y z z

(214)

v w y *v w y*

(215) (216)

even blackletter made use of the crisply oblique **v w** and **y** (208). Italic **a** is a somewhat condensed minuscule **a**, less its top; **f** *may sport a tail; and* **g** is nearer its capital original than is the basic minuscule **g** (146).

Whereas the endings (214) to ascenders and descenders do not impose themselves as a textual feature (although one must take care to avoid 'hairiness'), flags, beaks, loops or other such finishes can plague a book-page, and may link up into an unwanted, eyecatching chain of incidents. Ascenders and descenders perform according to the availability of interline space and their proximity to others above or below. These hazards are discussed later, as a behavioural rather than a structural theme (see p. 94).

Basic penmade capitals to accompany this formal italic script follow (217). They may be used at the same slant as the italic minuscules, or not. (In the

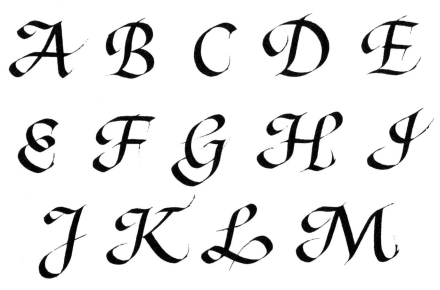

(217)

N O P Q R

(217)

S T U V W

X Y Z

sixteenth century, small upright roman capitals frequently ran with the italic text.)

The fifteenth-century Bâtarde style (218), in spite of E.M. Thompson's displeasure and its near total neglect by scribes in recent years, could well be included in today's repertoire. Graily Hewitt and Alfred Fairbank are silent in the matter, but Edward Johnston (although he makes no comment either)

a b c d d e f g h i j k l

(218)

m n o p q r z ſ ſ s t

u v v w w x x y z z

ABCDEFGHIJ
KLMNOPQRS
TUVWXYZ

(218)

makes tacit acknowledgement in his 'Six lines of Plato' (1934) – which uses a style that approaches it – of the relief from the suavity of roman minuscules afforded by the enhanced working-angle of the pen's edge and of the stimulus of at least a degree of prickliness, which it provides.

The Bâtarde style of the fifteenth century crystallized in the printing press. For an overall grasp of the style we cannot do better than take Victor Scholderer's view of the first printed books of the fifteenth century, whose promoters deferred wholly to the leading professional scribes in the matter of reproducing current writing practices in the printing press. He points out in his introduction to the French incunabula in the great British Museum catalogue that the early printers were for obvious reasons vitally concerned to render in type all the pothooks and curlicues of the penmanship they were mechanizing without, as Balbus's Catholicon of 1460 proudly claims, 'help of reed, stylus or pen'. Thus, Antoine Vérard of Paris, with a scriptorium of his own, epitomized his Bâtarde

scripts in the printed books that issued from his
press. And the English printer William Caxton
translated into his punches the alphabet of the well-
known scribe Colard Mansion of Bruges, who had
himself been caught up in the new technique of
multiplying manuscripts by mechanical means (219,
from Mansion's *Controversie de Noblesse*
(*c.* 1475)).

(219)

Prototype capitals and minuscules of Bâtarde have
been re-penned here with five lines of their
application in English. Letter **k** has been added; but
the heavily stressed long **S** of the Bâtarde alphabet,
which besides producing unduly heavy clumps
when used double in the text (219) is
somewhat difficult for the modern reader, has been
omitted from the lines in English. The example here
may therefore be termed a 'modern Bâtarde' (220).

Several lines of English in Batarde style. The omission of 'long s' increases its viability as a present day option.

(220)

Arabic numerals

We now use roman letters as numerals only on special occasions – mainly in commemorative work, for their dignity and grandeur. The conciseness of the arabic numerals – which led to the desuetude of the Roman system – effects a substantial economy over the roman numerals in space, penmanship and writing materials, for example: 1988 v. MCMLXXXVIII.

Clearly, arabic numerals will defer in size, weight, slant and angle of working-edge to the manner of employment of the pen in the capital and minuscule texts that they accompany (221, 222). There are two

(221) *From 1867 to 1892*

(222) *FROM 1867 TO 1892*

styles. First, the antique pattern (223): These have tops and tails, and in common usage, excepting **4**, and **1** and **0** (which keep within the guide-lines),

(223) *1 2 3 3 4 5 6 7 8 9*

they ascend and descend alternately. Secondly, the ranging numerals. These came into widespread use in the nineteenth century for printed timetables and similar settings. They are of uniform height and can align with capital letters (224):

(224) 1 2 2 3 3 4 5 6 7 8 9

The antique style is probably the more legible, but a penman would probably argue that the differences between the characters of the ranging style distinguish them sufficiently. Indeed, that uniformity of height which helps to make them relatively less legible can at times provide a welcome solution to a problem; for example, when pairs of dates 'rise' (225) or 'sink' (226) untidily together in an otherwise

(225) 1749–1826

(226) 1862–1953

carefully balanced piece of penmanship. However, because calligraphically the tops and tails of the characters of the antique style are in themselves an

attractive feature, and because it is the style traditionally used, the following description of the arabic numerals (taking them in numerical order) will concentrate on the antique style, and will mention the ranging form only where a comparison is useful, or where there is a notable finish that is characteristic of, or only available for, that style.

Numeral **1** has virtually the form of a dotless letter **i**. The triangular stem-head should perhaps receive a slight emphasis, and the foot may with advantage be – as here – small roman (venetian). It is vital that there should not be the kind of confusion between arabic and roman numerals that was seen during Silver Jubilee year (1977), when her Majesty was repeatedly designated upon souvenirs as Queen Elizabeth the Eleventh. Even in postage stamp denominations confusion of this kind persists.

Numeral **2** may be accomplished crisply and elegantly in one broken pen-stroke. However, a further movement – a downward and inward extension of the beginning with the left corner of the pen – may be needed to reduce an apparent vacuum in the concave space confined by the curve. Alternatively, a short, diamond-shaped stroke – characteristic of the ranging style – may be used.

Numeral **3** may be performed simply, in one broken stroke, the first movement not quite reaching the lower guide-line, and the second ending in the

space below it. Additions to the top and bottom endings of antique numerals add too much weight, but might well be permitted to ranging characters. An alternative, horizontal, top is sometimes seen. With this top, **3** aligns well with **5** and **7**, but might be mistaken for the tailed variety of minuscule **z** (208, 214), or in certain situations, at small scales, for **5**.

(227)

The descender of **4** is all that remains of its medieval ancestor's tail (227) after the 45° anticlockwise straightening-up process. The 30° working-edge angle ensures a correct emphasis on the stem, which may end either with a small roman (venetian) foot or, preferably — as here — with a mere removal of the pen south-westwards.

Numeral **5** begins rather thinly with a stroke that breaks acutely into a descending lobe of the kind already found in **3**. And, like **3**, it has on occasion been seen with a short terminal stroke. Its top is a dash with an appropriate ending.

Numeral **6** is written as for nought, but with its first stroke commencing above the upper guide-line. It is not unlike an inverted numeral **9**. Consideration may be given to the addition of a short beakhead, as is done in minuscule letters **c** and **s**.

Numeral **7** begins its one broken stroke as for the head of **5**, and continues diagonally, like a **z**, down

into the space below the lower guide-line, ending sharply, leftwards.

Like capital letter **S**, numeral **8** is a matter of a diagonal stem bridging two curved strokes and enclosing somewhat more space below than above. (But, again like **S**, it is not merely a cottage-loaf-like shape, with one circle resting on a slightly larger one.) The middle point of the bridging stroke does not reach the upper guide-line and the top loop rises to the level of **6**'s ascender. It is a subtle letter and repays the intensive pen-practice required to accomplish it well.

Numeral **9** may fairly claim to be **6** the other way up. Its head occupies most of the space between the upper and lower guide-lines, and its tail ends in the interline space below, usually without a terminal stroke.

Punctuation

Having given attention to majuscule and minuscule scripts of several kinds, the matter of punctuation must also be examined, since transcription cannot very well manage without. (In passing, it may be noted that written legal documents have tended to omit all punctuation, ostensibly on grounds of clarity, confused punctuation being far worse than none.)

Most of the later Roman stone inscriptions employed small marks rather than spaces for the separation into words of letter sequences. These stops are usually triangular (228), frequently having their three faces 'dished' or incurved (229). Some are ivy-leaf shaped (230), with stalk (231) or with stalk and stem (232). In certain inscriptions that use letters with rounded serifs, trefoil stops were employed (233). In some instances space was contrived between words to accommodate such marks, but in many other cases they made shift as best they could, even being driven inside the letters **C D G O** and **Q**. There is no call for such stops nowadays; space between words is considered sufficient. But if sense and clarity are not adversely affected, then a modern scribe is free to indulge in marks of his own devising, especially among the capital letters.

According to E.M. Thompson, the classical transcriptions in Latin majuscule bookhands are generally devoid of punctuation. The scribe, however, following the national bookhands of later medieval times, and after five centuries of print, must study and use the present, settled system of punctuation (as listed and discussed in, for instance, *The Oxford Dictionary for Writers and Editors*). For the precise structure of the punctuation marks the pen remains our sole guide. The scribe is arbiter of their arrangement.

(234)

(235)

(236)

(237)

(238)

The form of the *apostrophe* – originally dictated by the pen – is achieved by a very short clockwise downward stroke (234). The pen held at the working-edge angle of 30° from the horizontal ensures a full-weight start and a sharp ending. The apostrophe is used singly for letter-omissions, and for the closure of single quotes (235). The opening quote is formed by a penmade reversed curvature. It is a very short stroke which begins with the pen's thin edge and curves downwards anticlockwise, to stop abruptly at its heaviest. (Type face design prefers the uncalligraphic blind 'numeral' shapes **6** and **9** (236).) Double quotes or inverted commas are simply a pair of such marks at each end of the phrase quoted (237).

The *brace* is likewise a calligraphic structure (238). (It is perhaps somewhat more copperplate-like in print than in formal script.) The pen will produce a

sharp start, but unless a good flow of ink combines with a perfect pen-lift onto one point it can hardly avoid a substantial ending. The brace may be anything between soberly vertical and fetchingly willowy.

(239)

Brackets present no problem. They begin and end with a short horizontal stroke on the containing side and extend vertically to include ascenders and descenders in the text (239).

The *colon* is a simple affair of two pen dots, one above the other. It might be thought reasonable if the upper dot were level with minim tops and the lower one with minim feet, but among stems of five nibwidths high (or more) this distance would seem too great (240). A centralized grouping separated by only one nibwidth would be better (241). Even their touching in one broken stroke should not be ruled out (242). In the past, particularly in the blackletter era, the two colon dots were sometimes treated in fanciful ways and there seems no reason why the modern scribe should not do likewise (243).

(240) (241)

The 1981 edition of *The Oxford Dictionary for Writers and Editors* seeks to discourage the practice of placing a dash after the colon when reaching some heading, list or table. The Oxford University Press have no name for this combination, which may be seen in medieval manuscripts (for instance, in the Winchester Bible (W, f. 170 V.)) (Plate 4).

(242) (243)

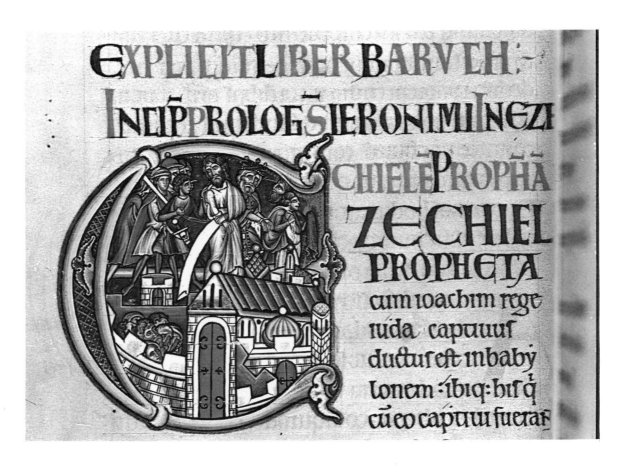

Plate 4: The Winchester Bible. w, f. 170 v. 12th Century. Headlines of coloured capital letters with variants of Roman forms — round E, and adventurous square C and G. Also the colon and dash sign which leads the reader on:—

The form of the *comma* is the same as that of the apostrophe (234).

The *dash* presents no difficulty. In typography the em dash (a short one) signifies a pause between two distinct but related thoughts; the two-em dash (a longer one) is used in cases where a word is for some reason not to be spelled out. The dash is formed by a simple horizontal stroke, not unlike the top of capital letter **T** (244), placed up to a letterspace away from the nearest words. It may be done soberly, or it may relax into something like a shallow ogee (245), but in either case it comes in from the south-west and ends with a pen-lift to the north-east.

(244)

(245)

The *exclamation mark* can be something of a difficulty for the scribe. Present-day printing has arrived at a rounded, heavy top which diminishes downwards to a fine point and surmounts a round dot of similar weight (246). Without steadily twisting the working-edge from thick to thin during the downward stroke such a shape would be virtually impossible for the pen (and in any case both top and dot would be angular). The solution is to bring the main stroke straight down, ending it thinly to the south-west; to add a bracket to the head; and to align a penmade dot vertically below (247).

(246)

(247)

The *full stop* is merely a square pen-dot, placed so as to align with the stem feet that end the sentence. It

should appear to be neither falling below that level nor floating above it.

The *hyphen* is performed precisely as for the dash, but is very much shorter (248).

Parentheses suggest a choice of two treatments. The first involves the pen's edge being used at the usual working-angle, so that the pair differs little from the left-hand and right-hand strokes of a capital letter **O** (249). The second involves a sleight of hand in which the pen's working-edge is turned clockwise 30° to produce the same form on both sides of a vertical axis (250).

The *question mark* offers a number of options to the scribe over its construction. The pen may simply swoop downwards in a clockwise curve, rather like a long comma, and then turn sharply south-east to end in a dot (251). Having done this, it may return to the beginning to add a short, tucked-in stroke (252). If this is felt to be insufficient, an additional dot may be placed below (253). Should this be felt too busy, the swoop may end in a linear hook (254). And should all these be felt unsatisfactory, at least one other variation is available (255).

The *semi-colon* is normally formed in two short, independent strokes; a full point above and a comma below – preferably not too distant from each other (256). In the blackletter style the two

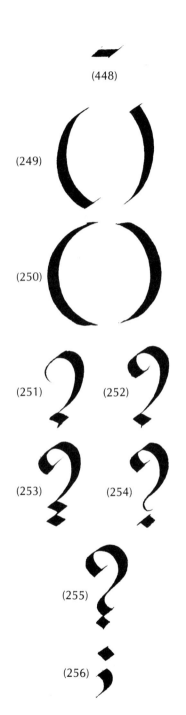

(448)

(249)

(250)

(251) (252)

(253) (254)

(255)

(256)

(257)

(258)

movements may be linked without the pen being removed from the writing-surface, the stroke terminating in something of a flourish (257), and the resulting form looking not entirely unlike a variety of minuscule **z** (208, 214).

The spacing for, and the style and weight of, all these marks of punctuation must accord with that of any script they accompany; the rhythm of the letter-flow must remain unimpaired.

Certain other literary signs are also commonly associated with the apparatus of any specific alphabetic style. In their treatment the scribe will follow the pen's own solution – the asterisk being a daunting exception. (However, see (258).) For the basic structure of technical symbols – mathematical, chemical, geographic, botanic and scientific generally – reference may be made to the British Standards Institution. For almost all of these, the pen will indicate an appropriate presentation.

Part II: SPACING

Letters into words

Where letters are analysed and practised to perfection, their arrangement into words – and that of words into lines, and of lines into columns and pages – should also receive the utmost care and consideration. The internal arrangement of written words is of paramount importance, not only because they are the significant units of visual communication – and therefore must be readable – but also because their manner of presentation is of great aesthetic importance.

It is only fair to point out that one school of thought, maintaining that variety is the spice of life and that all will be best when without concern, advocates deliberate laisser faire in the association of letters. This is a convenient stance, saving a deal of effort, and the results are familiar enough.

Stanley Morison (in a typographic context) endorsed the view that indifferent letter form well spaced does better than the reverse. The normal criterion for most photo-setting systems for print is the matter of cost. Tight spacing of a type face undoubtedly saves paper, the more so on a lengthy print-run, and the same will apply to penmanship. Although blackletter scripts were a natural development towards economy in costly writing materials, the experienced professional penman

would never go so far as to squeeze letters together as in the tightest letter-spacing of modern print. In the one-off high-quality manuscript today, whether for reproduction in facsimile or not, the optimum spacing of letter stems is to be sought. How is it to be achieved?

For the purpose of spacing and arrangement, words may be seen as sequences of letter stems — some curved, some oblique, some vertical, some composite — woven into a 'text'. Balanced spacing is to be sought using these materials. In spacing, the letters must complement one another. Whether they are compressed or generously open the progress of the other units of the text should be complementary. Although, of course, complementary spacing is not achieved simply by treating the vertical components of letters as though they were like the rungs of a ladder lying on its side, it is useful to keep that idea in mind (259). The regulating of the spacing of

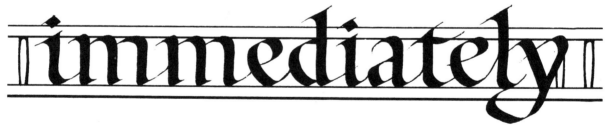

(259)

letters to achieve a satisfactory visual balance by means of the idea of a ladder may be made more exact (and more useful) by formalizing it as a

notional grid (260). It will be seen how capital letters
– **M**s and **O**s of, say, four units wide, **N**s of three and

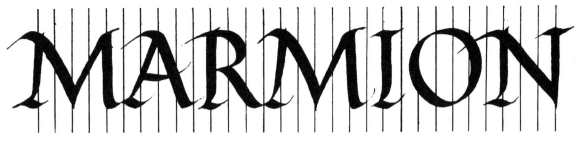

(260)

As and **R**s of, on average, two – require just about
two units between letters for a fairly evenly spaced
letter-flow. In the case of minuscules (261) there is a
rhythm of two units, which is disrupted after three

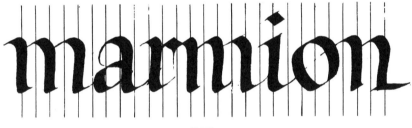

(261)

strokes of **m** by open-sided **a** having to move in
closer to **m** by half a unit. **r** follows at two units
distance, but being open sided has to pull **m** towards
itself by half a unit – at which point the original
rhythm is recovered, and maintained to the end of
the word.

Although such aids to the achievement of a
balanced spacing of letters are useful, none is fully
adequate. While roughly half the 'rungs' are
vertical, the rest are not. The units of the notional

grid essentially measure horizontal distance and thus do not take full account of the forms of letters. The ladder and grid assume the conformation of letters to a vertical structure. Therefore it is necessary to arrive at a more adequate formula for their arrangement.

Ben Shahn, the great American lettering artist, tells of his attainment of a sense of spacing; the small measuring glass holding just so much water for each space between the letters, containing the same amount of water, whatever its shape. Sometimes the shape will be rectangular, sometimes triangular, sometimes definite but nameless, but always quantifiable. These quantities are areas. Thus, as a rule, it is the area confined by the parts of a letter and that between letters, not the horizontal distances between the parts nor that between letters, that are the values to be taken account of in the formation of a balanced sequence. For instance (262), the background area between **T** and **H** – allowing for the right-hand side of **T**'s top, which cuts slightly into the otherwise rectangular shape between **T** and **H** – is to equal both that between **H** and **E** and that of the two internal areas of **H** added together. Like the aid of a 'ladder' or grid, this rule cannot be applied mechanically. The penman will regulate spacing by an eye that acknowledges it (263).

It will be a great help to the scribe in spacing to become acquainted with the characteristic shapes that will occur between well-spaced letters. If we

(262)

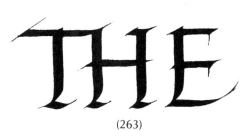

(263)

assume that the capitals remain within upper and lower guide-lines, then between **A** and the rest of the capital letters we get the following variously shaped areas (264): Out of these twenty-six inter-

AA AB AC AD

AE AF AG AH

AI AJ AK AL

AM AN AO AP

AQ AR AS AT

AU AV AW

AX AY AZ

(264)

letter areas, no less than fourteen resemble (265). Four resemble (266); two (267); two (268); one (269); one (270); one (271); and one (272). Frequent

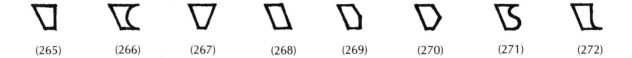

(265) (266) (267) (268) (269) (270) (271) (272)

use will perfect the performance of the first, but the performance of the remainder will need to be practised. Similar attention will need to be given to other, less frequent shapes that result when each of the other letters is paired with the alphabet in the same way. Between **a** and the rest of the minuscules we get a different set of shapes (273): Although, of

(273)

aa␣ ab␣ ac␣
ad␣ ae␣ af␣ ag␣
ah␣ ai␣ aj␣ ak␣
al␣ am␣ an␣ ao␣
ap␣ aq␣ ar␣ as␣
at␣ au␣ av␣ aw␣
ax␣ ay␣ az␣

course, not all combinations occur in any one European language, the persistent scribe will deliberately explore all the combinations of capital letters, of minuscules, and still more of capitals with minuscules. Familiarity with them all should ensure an even written word-flow.

Beyond these general aids to spacing there are some particular considerations that may be dealt with immediately. First, should we consider the interior spaces of letters **C E F G S** and **Z** to be shut off from the space that follows it, or are the two spaces to be evaluated as one? The answer will depend on whether the letters are from a very heavy alphabet (one with very little space contained between stems) – for instance (274) – in which case they are not; or are of a lighter weight but with serif-ended stems that debar entry (275) – in which case

E

(274)

(275)

not; or are of a lighter weight, without such a serif bar – in which case they may have to be. Whether letters are 'open' or 'shut', we must make visual allowances accordingly.

Secondly, the recession of certain letters – **A F J L O P Q T V W X Y Z** and **a c e f g k o r t v w x y z** – tends to create a vacuum by adding the space left by the recession to the adjacent background space. Some letters by reason of that recession are

particularly disruptive to a spacing system when combined. For example, **LJ** (as may be readily seen in car registration numbers), **LA** (276) (where violent

BALACLAVA

(276)

evasive action is called for (277)) and **rv** (278). A

BALACLAVA

(277)

curve

(278)

rough solution is to accept some degree of space penetration into letters open on one side and where possible to reduce their distance from the nearest notional whole-stem by, say, a half. For example, not (279) but (280); and not (281) but (282). As the

(279) (280)

(281) (282)

result of doing this, other adjustments may need to be made: in the last example, a shorter top stroke to minuscule **r** assists the rhythmical spacing of letter stems that follow. And if **L** shortens (51) or shares (284) its lower stroke fractionally, the reduction can be made and a balanced word should result.

(283)

Thirdly, it is essential to resist the fitting together closely of certain pairs of letters that especially tempt it — letters such as **A** and **W** (283) — simply

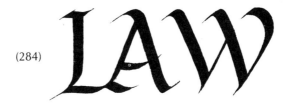

(284)

because it may be possible to do so. Bearing in mind the space within each of these letters, they must be kept apart an appropriate amount (284).

The spacing of formal italics is similar to the spacing of basic minuscules. Except that certain problems are not present — those arising from open-sided **a** and the vagaries of **g**, for instance — all is as with the minuscules, each stem being unerringly placed, as part of a continuous movement, at the

only visually balanced distance from the stems already made (285).

(285)

The spacing of arabic numerals is no different in principle or practice from that of letters of the alphabet – a date, such as **1066** or **1987**, may be treated for the purpose as a word. Obviously, both style and spacing should defer to those of any script they accompany.

The spacing of antique style arabic numerals is, frankly, hard to describe and demonstrate in the absence of upper and lower limits. They must be spaced wholly by eye to accord with the visual rhythm of the script in use (221).

The spacing of ranging numerals, on the other hand, which do run between upper and lower guide-lines, matches that of capitals (222). Figure **0** will echo letter **O**, adopting its wide or narrow proportions. Figure **1**, when following figure **0**, will yield the inter-figure shape (286), figures **1-2** (287), figures **2-3** (288), figures **3-4** (289),

(286) (287) (288) (289)

figures **4-5** (290), figures **5-6** (291), figures **6-7** (292), figures **7-8** (293), figures **8-9** (294), and figures **9-0** (295). (Of course, these are only a few of the shapes

45 ⅚ 56 ⅚ 67 ⑸

(290) (291) (292)

78 ⚖ 89 ⅚ 90 Ⅱ

(293) (394) (295)

that result from such pairings.) The inter-numeral spaces should correlate with the inter-letter spaces, taking their place unobtrusively in the text-flow.

The penman, having acquired a sensitivity to the spacing of letters and numerals, may from time to time check his skill by pausing to analyse groups of three adjacent letters within a word such as **MARMION** (260). Masking the rest, he should ask himself such questions as: Is **A** optically central in the group **MAR**? If so, is **R** central in **ARM**? **M** in **RMI**? – and so on. In this way visual assessment is kept sharp.

Some refinements the need for which is noticed by an eye made acute by such methods are difficult to make in practice. For example, shapes can and do affect each other's appearance when juxtaposed: a letter such as capital **O** will almost certainly lose something of its symmetry when lying between a concavity and a convexity, as in the letter sequence **LOG**. One might argue here quite apart from any

spacing formula that **O**'s left-hand curve should appear to react outwards to accommodate the vacuum, and that its right-hand curve should appear to react either inwards to avoid a clash or outwards in defiance of encroachment. However, whatever the truth here, and while no factor should be completely ignored that could lead towards visual perfection, one could hardly stop to calculate this in a fast-flowing sequence of letter forms. It must be automatic.

In the interests of good spacing and a rhythmical progression of letters, wherever situations demand it, the reconciliation of thick with thin strokes is necessary. To achieve it, even the sharing of strokes may be employed, providing the result is acceptable on its own, and not merely in context. Unwanted gaps in such frequent combinations as **ry** and **tt** can ruin a smooth letter-flow. In the case of **ry**, by restricting **r**'s second stroke to something like a diamond shape close to its main stem (296) and beginning **y**'s first stroke immediately on ending **r**'s second a gap will be avoided. Unwanted space may also be lost by beginning **y**'s first stroke in the middle of **r**'s normal, unrestricted top stroke (297). Undue space between **r** and **a** may be similarly reduced. The broken stroke formed by the joining of **r**'s second and **a**'s first may be either pointed below (298) or ogee (299), according to the scribe's pattern of work.

On occasion, more drastic measures may need to be taken to achieve a balanced, well-spaced

(296)

(297)

(298) (299)

sequence of letters. We have seen, for instance, how in classical times for the sake of even spacing **T** was frequently given its head above the other letters in a sequence of capitals (73); an option which remains for us on occasion even today. It is possible to amalgamate, εven to interlace, letters in the same cause. (And indeed certain pairs of letters seem to demand such treatment.) For example, the interlacement of two **O**s, either capital or minuscule, can be a solution to a spacing problem when lateral space is at a premium. But there are conditions for its success. Normally one stemwidth between **O**s is the least space to be allowed if they are not to be amalgamated or interlaced (300). When this is reduced an unacceptable visual confusion takes place (301). The unduly heavy area resulting from actual contact (302) is as unacceptable. An honest mutual biting of lobes, where excess weight is absorbed, is better (303). Without due care interlacements will form unduly heavy areas (304). Boldness is the key. The ideal interlacement is one in which the three internal areas are roughly equal (305). Such spatial economy is only slightly diminished by wider **O**s. Narrow ones would tend to reduce the amount of visible background substantially (306). Awkward conjunctions of minuscule letters also occur; the

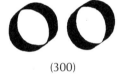

(300)

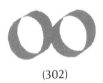

(301)

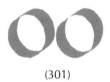

(302)

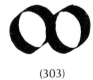

(303)

(304)

(305)

(306)

following problems and solutions are typical: (307),
(308), (309), (310), (311), (312) and (129).

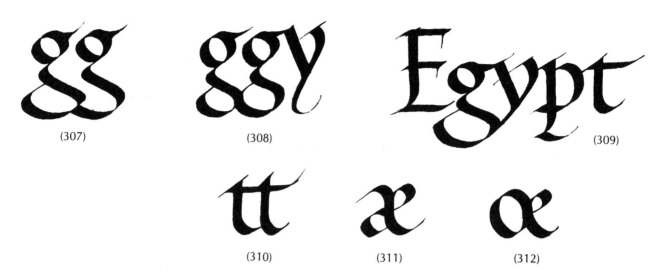

(307) (308) (309)

(310) (311) (312)

Diphthongs æ and œ are essentially biters anyway.
Italic characters being more adaptable and more
open to adventurous treatments, the possibilities of
their manipulation to achieve a balanced sequence
are left to the scribe to investigate.

Ciphers and monograms

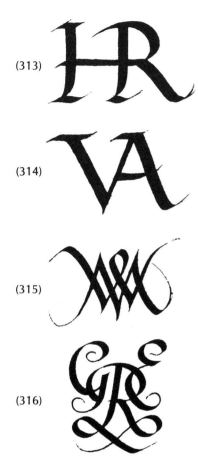

(313)

(314)

(315)

(316)

The cipher and monogram in penmanship provide exhilarating possibilities of interlacement and amalgamation. Monogrammatic initials share one or more stems (313) 'Henricus Rex', and (314) 'Victoria and Albert'. Cyphers simply interlace stems (315) 'William and Mary', and (316) 'George Rex and Elizabeth Regina'. (At times, letters may even be reversed, not quite as straightforward a thing in penmanship as in monoline treatments.) Three things are requisite for their proper formation – that the arrangement of letters be orderly and clear, that the letters be of good shape individually, and that the resulting background areas be reasonably balanced. Beyond these requirements, sensitivity combined with adventurous experiment is likely to hit upon the best answers.

Roman inscriptional artists were not above perpetrating the most atrocious cannibalisation of letter stems. Emil Hübner's example No. 565 illustrated here (317) will serve to indicate something of the athletics that a reconstruction by pen would have to face in reproducing it (if indeed that were possible). Its contractions are: **P.VIRUCATE/P. F[ILII] MAXUMI ET VALERIAE/P. F[ILIAE] URSAE ; P[UBLII] VIRUCATE.** Edward Johnston in *Writing, & Illuminating, & Lettering*

illustrates another such example (from Hübner's No. 384), wisely, perhaps, without comment (318).

P·VIRVCATE
P·F·MAXME·VALERIAE
P·F·VRSAE·P·VRVGE

(317)

SPENDONTI
C·STATI·PATERCLI
Q·STATIVS·MVRRANVS
SODALI

(318)

Words into lines : lines into text

This chapter deals with the spacing of words within lines and of lines on a page. First, the spacing of words. Although it is true that the closer together the letter stems within words, the less the space needed between words to secure a visual separation, which is the desired result, as a general rule this will be secured if letter **o** of the minuscule alphabet in use were to have just enough room to drop between any pair of adjacent words in the text (319): However,

space between words

(319)

such word-spacing might be thought minimal; **o** and a quarter might be better. Probably, **o** and a half would be over generous, and certainly, two **o**s altogether too much.

In any sequence of lines there is risk of interword spaces coinciding vertically and forming 'rivers' of white background. This is especially so where words are far apart: it is less frequently the case in 'tight' calligraphy. The rule for word-spacing suggested here – that there should be only enough space between words to secure a visual separation; and that something like the width of an **o** will secure

it – will considerably reduce the risk of producing such 'rivers'.

Next, the spacing of lines. One of the first considerations when forming lines into a sequence is the amount of space to be allowed between them. A space must be found that avoids clashes of ascenders and descenders without creating too 'stripey' an appearance to the page. (Few manuscripts of the past avoid the effect of strong horizontal bands.) To avoid all interline clashes between ascenders and descenders of any script, tails from above and tops from below must always be just out of reach of each other. But then, ascenders and descenders may perhaps be shortened, in which case the interline space may be correspondingly less, down to, say, one-and-a-half minims high. Edward Johnston pointed out (in *Writing, & Illuminating, & Lettering*) the difference between what he termed 'massed' and 'fine' writing, respectively interline spacing of one and three minims. He did not much mind the risk of tops and tails clashing in the cause of well-spaced lines (see *Formal Penmanship*). It is possible to develop a habit of leaving off temporarily all descenders when writing along a line so that ascenders from the next line below may have a chance of the evasive action that we shall be discussing shortly. An extreme example of a 'stripey' page (although it is not so as a result of an effort to avoid interline clashes) is a diploma issued by Louis the German, dated A.D. 856 (St Gall. Chapter Archives F.F.i.H. 106), where

the interline space is at least twelve minims high (the ascenders extend almost to touch the lines above, miraculously with only a few scrapes and a lot of near misses). By contrast, an example of an almost stripeless texture is to be found in a French mid-fifteenth-century script of Romances (B L Royal MS. 15 E vi), where tops and tails are truncated and interline space is considerably less than one minim high (320). I think we should be content with

(320)

Johnston's interline space of not more than three minims and not less than one. This should allow ascenders and descenders a satisfactory amount of space and should avoid excessive stripes.

A second consideration when forming lines in sequence is length of line. A handwritten document of any kind will be easier to read where there is no difficulty in picking up the next line after a long traverse back from the far end of the previous one. If the page to be written across exceeds that distance by much the answer may well be columns. Given that ten to twelve words to a line in the English language forms a span that allows lines to be comfortably picked up and that the average number of letters in an English word is five and a half, then including interword spaces and taking an average letter width the optimum line length will be something like sixty calligraphic units. While all of this is open to personal inclination and argument, typographic studies confirm that between fifty and seventy characters, including interword spaces, form a line length that ensures that the eye may comfortably track the text.

The space between lines on a page is not the only aspect of line-spacing that needs to be discussed. The merits of the right-hand edge of a page being as flush as its left-hand edge should also be considered (as should the achievement of a flush left-hand edge, for which see p.105). A ragged right-hand edge to a text will occur if letter- and word-spacing remain constant and words are written in full. Some lines will in this way fall short of the measure while others will exceed it: the longer the lines the less noticeable the discrepancy. 'Justification' is the term used by typographers to describe modification to a

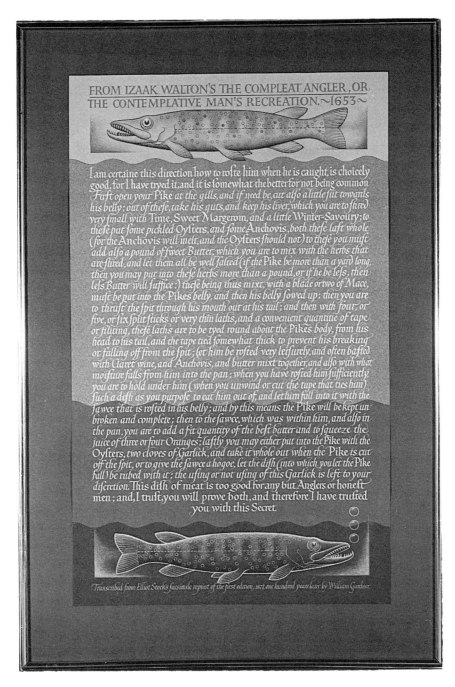

"Roste Pike". A receipt by *Isaac Walton*, 1653.
Within a moulded silver frame of inside sizes 49 cms wide x 75 cms high. The calligraphy is in a 'soft white' penmanship; upon Papiers Canson – from the top – Pearl (343), Felt Grey (429), Steel Grey (431), Slate (345), and Tobacco (501). The heading is in red versal capitals. The upper pike is tinted with water colours; the lower one is white only. Transcribing the long receipt which swings between capitals, minuscules and formal Italic letters, and is laced with two kinds of the long S' of the day, proved a challenge in the avoidance of erasure. William Gardner, undated.

system of spacing in the interests of an even right-hand text-edge — a modification to which the penman cannot very well submit. The division and hyphenation of terminal words will achieve a flush — or less-ragged — edge. (The rules for hyphenating or dividing words are given in *The Oxford Dictionary for Writers and Editors*.) But if we do not mind a somewhat ragged right-hand edge, we may not need to break up terminal words in this way. In most early manuscripts, while the left-hand edges of texts conform vertically almost without exception, right-hand edges often take their course, with the occasional flourish into the vacuum (Book of Kells) or contraction wherever a terminal word would otherwise project too far into the margin.

Contraction, as a way of creating a less-ragged right-hand edge, is hardly available to the modern penman. The contraction of English words these days and more especially the use of groups of initial letters standing for them run the risk of evoking meanings other than those intended.

(Professor Ullman in *Ancient Writing and Its Influence* reminds us that abbreviations, suspended or contracted, are generally absent from formal writing nowadays.) The penman will wisely inscribe in full whenever possible.

However, flourishes into vacuums as a way of reducing the raggedness of the right-hand edge of a text are available to the modern penman. In the thirteenth and fourteenth centuries, line endings

frequently took the form of either penmade decorations of minim height to the distance required (321, from Valerius Maximus, 'Memorabilia', Tournai 1404, Paris Bibliothèque Nationale, Lat. MS. 16028) or rectangular panels containing

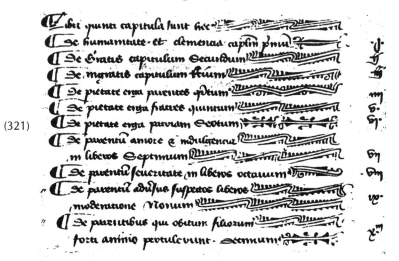

(321)

geometric or foliate motifs rather than the flourishes we noted in earlier manuscripts. For the attainment of a flush right-hand edge it is doubtful whether scribes of today would go so far as to press into use lengths of animal or floral drawings or penmade panels, but the discreet use of flourishes is a permissible, if partial, solution (119). Certain capital letters lend themselves to extension on occasion (322, 323), and certain minuscules too: **k** (156), **q** (168), **r** and **z** (169, 214).

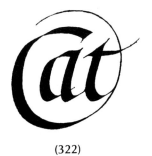

(322)

(323)

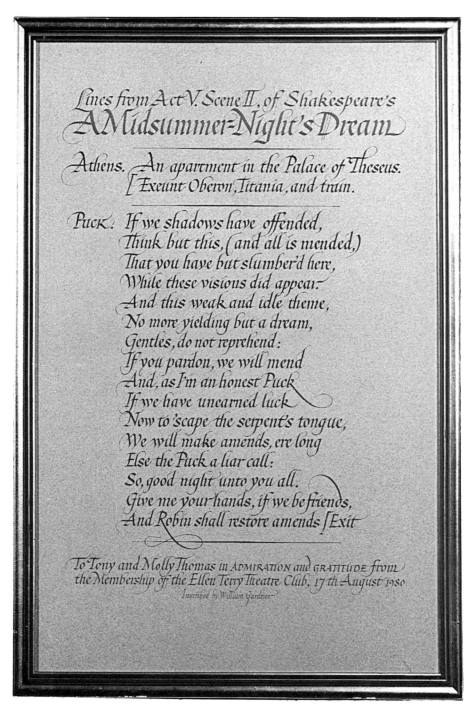

Presentation Piece.
From Act V. Scene II of Shakespeare's "A Midsummer Night's Dream." Inside dimensions of moulded gilt frame, 31 cms wide x 46 cms high. In a compressed formal Italic hand, the quotation is written in sepia upon Papier Canson Moonstone (426), with heading and dashes in red. William Gardner, 1980.

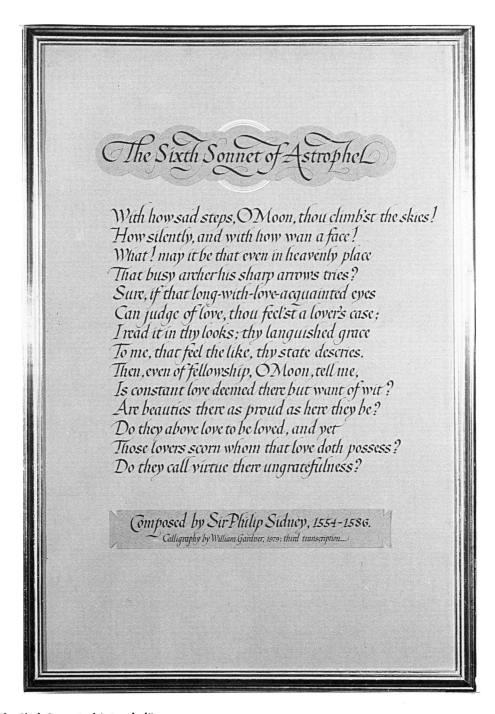

Plate 5: "The Sixth Sonnet of Astrophel"
By *Sir Philip Sydney.* In black calligraphy of an open formal Italic hand. Written upon Papier Canson, Pearl (343) with laid title and colophon panels of Sky Blue (354). A moulded silver frame with inside dimensions of 36 cms wide x 53 cms high. William Gardner, 1979.

The flourish as well as being deliberately contrived as a space-filler may also either be otiose activity in the interline areas and elsewhere or serve, if judicious and well placed, to balance a passage or composition (Plate 5). Those flourishes that spring from the heads and feet of formal script letters (more especially perhaps in italic) as extensions of strokes are most familiar. It is of interest in passing, that the spread of literacy and therefore of cursive handwriting brought with it a concern for authenticity. Security was sought in the individuality of flourished interlacements called *paraphs*. Four examples are given opposite from a selection of documents – the signature and paraph of King Henry VIII, 1530; those of The Princess Elizabeth, 1552; the signature and paraph of Mark Bradley, 1627, from the Common Paper of the Company of Scrivenors of London, and those of Neale Sheldon and another, from an indenture of 1716. Most of the typographer's 'swashes' are the real preserve of the penman. Here is a selection of some used – at times, almost abused – in sixteenth-century calligraphy (324, from Gerardus Mercator's *Literarum Latinarum* (1540)): Although these possess strong leanings towards an extrovert copperplate style, and indeed afforded the copperplate style its beginnings, they are valid as penwork. It will be readily understood how busy and restless interline spaces may become from unrestrained flourishing of ascenders and descenders. Flourishing is a highly sensitive part of the art: the skill lies in knowing not

Signature and paraph of Marke Bradley

Princess Elizabeth 1552 Marke Bradley 1627

Wittnesse

Neale Sheldon 1716

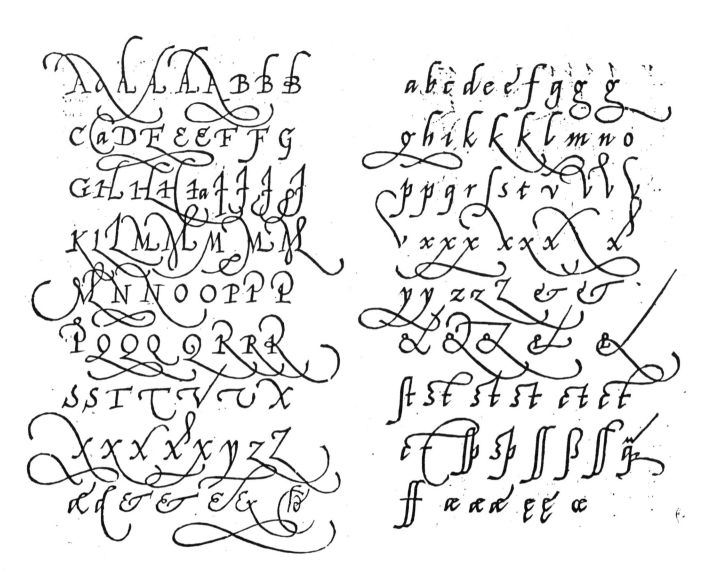

(324)

U
N
W
I
T
T
I
N
G
L
Y (326)

I
N
V
E
S
T
I
G
A
T
E (327)

A
B
C
D
E
F
G
H
I
J
J
K
L
M

N
O
P
Q
R
S
T
U
V
W
X
Y
&
Z

(328)

only how to respond to a need but equally when to refrain.

In flourishing, the utmost care should be taken to avoid a repetition of eye-catching strokes or short and heavy flourishes at the ends of ascenders and descenders. The repetition of these will disturb the appearance of a text as much as will the hairy texture produced by repeated hair-line endings. A discreet lead-in or lead-out top is acceptable, including bracketed lead-ins, but exaggerated flags are not. These, which are nearly always of directionally heavy strokes, when used unremittingly throughout a text create the impression of a forcefully wind-swept page.

In the appearance of a page of manuscript text the vertical flushness of the left-hand edge is usually taken for granted. Yet the achievement of this is by no means as simple a matter as it might seem. For although both capitals and minuscules may be placed one above another, touching a vertical line the result is by no means optically flush (326, 327). While vertically-stemmed characters without a top or bottom stroke that begins to the left of the stem naturally experience no difficulty in their alignment, capitals **A C G J O Q S T V W X Y** and **Z** all tend to 'recede' from the line. Corrective action is possible (328). The horizontal pen strokes of **J** and **T** may project through the line without visual offence. In the case of obliques **A V** and **W**, their first strokes should be placed so that their optical centres align, **C G O** and **Q** are best positioned with the line

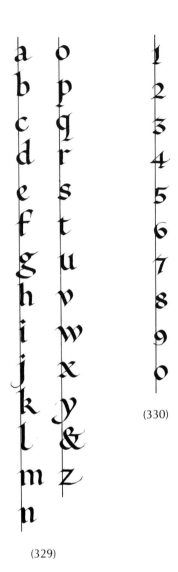

a b c d e f g h i j k l m n

o p q r s t u v w x y & z

(329)

1 2 3 4 5 6 7 8 9 0

(330)

touching the inside of their left-hand curves. Composite shapes **X Y** and **Z** may seek alignment by breaking through the line slightly. In minuscule script (329), receding letters **w x y** and **z** need to begin slightly to the left of the line; **c d e o** and **q** require alignment along the inside of their left-hand curves; while optical placement is required for composites **a g** and **s**. No alignment problems attach to the rest. A flush left-hand edge for formal italic scripts and for arabic numerals (330) may be similarly achieved.

Part III: PRACTICALITIES

Work-bench and chair

The work-bench or table of standard height (2ft 6ins) and the seat of standard height (1ft 6ins) should both be strong and steady. A ricketty table or bench which causes pencils, pens, brushes and drawing instruments to roll and rattle against each other during the work, which can be distracting, is likely to affect the sensitive contact between pen and writing-surface and should not be used; nor should a shaky chair. A cloth cover to the working-area of the table or bench is less stark than bare wood. It is perhaps best fitted and stretched by means of battens nailed under the bench edges. A generous overall working-area is desirable – say 8ft wide by 4ft deep – so as to accommodate a copying-lectern, books of reference, the writing-board itself, a table lamp, inks, pigments and writing instruments. For the latter, shallow, plastic horticultural trays are useful, and some have found a tea or hospital trolley on wheels at the chair-side useful for carrying supplementary materials and equipment.

For sustained penmanship a working-chair of the kind used by typists is particularly suitable. This has a seat of cloth-covered foam rubber and a back support of the same material at waist level. The armless version permits greater freedom of action. Adjustable seat-height can obviate the need to

stretch up to the top of a tall writing-surface or to crouch down to uncomfortably low levels. The swivel action of such a chair gives ready access to instruments and other items spread around the working-area. But a chair with castered feet could move too easily and thereby cause uncontrolled movements of the pen: trailed, non-rolling feet are better.

Writing-board

The method of resting the writing-surface has gained in elaboration over the centuries. It has developed from the simple propping of the work upon the lap, through the use of boards resting on extensions from the scribe's chair, and the use of lecterns with ink-horns and holes for pens, to the ultimate sophistication of an adjustable writing-board on a cabinet-like desk with storage space underneath and a rack for books.

The adjustable writing-board shown overleaf, well made from seasoned wood, with a surface area of something like 2ft 3ins wide by 1ft 9ins high, is hinged at the bottom to a base of the same size. Hinged arms working together upon ratchets serve to control the board's angle of elevation. An angle-ended cup-hook (332), screwed into the centre of the front edge of the base of the writing-board and turned downwards, will engage the bench edge and prevent the board sliding away under writing pressure. One hook is best since this allows the board to be swung in relation to the source of light. The hook is easily unturned 90° when not required. Because a writing ink flows from the pen's working-edge with the help of gravity as well as through capillary action, the angle of pen to writing-surface affects the flow. A thick, rather viscous ink may

(332)

The Author's Work Bench.
A folio of two inscribed vellum leaves for a manuscript Regimental Memorial Book lies on the adjustable board. Writing instruments, with a tray of accessories and other equipment are closely to hand.

WRITING-BOARD 112

require the board lowered towards the horizontal, while a thin, runny ink may need the board tilted nearer to the vertical, so that the pen lies almost horizontally in the hand.

will control flow of ink to a ft. extent
Writing at a steep slope (the steeper the
better up to abt. 45°), as the ancient
scribes did, is even more effective, as
the pen shaft may be held nearly level
thus

slope penshaft

(333)

 A smooth, hard surface under the writing-material is by no means the best for sensitive penmanship, and several thicknesses of paper (or a sheet of blotting paper, even a layer of cloth) underneath will provide a degree of 'cushion' essential for good definition, since in this way the pen's working-edge will be assured of satisfactory contact over its full width (333). Having stretched this cushion layer with adhesive tape by its side edges onto the writing-board, a guard sheet of stout paper or thin card is positioned over it so that the pen-holding hand when at its most comfortable working station rests

just below the top edge of the guard sheet, which may then be similarly secured by its side edges. The writing-material is inserted between cushion and guard sheet, and is pulled up a line at a time during the course of the work. In this way the unused part of the writing-material is protected both from accidental releases of ink from the pen and from the effects of a hot, damp or greasy hand. The whole work sheet (provided the ink has dried) may be pushed back under the guard sheet between stints of writing. Larger works will, of course, require larger boards, propped up and used in the manner described above.

Skins and papers

The material for leaves of a manuscript book, or for single-sheet documents such as diplomas, certificates, testimonials, warrants of appointment, etc., is traditionally either vellum or the less-expensive parchment; but high-grade papers of suitable quality are also available (Papiers Canson Mi-Teintes, for example – see p.122 below). It is an inaccurate generalization to describe all writing-skins as parchments. Parchment is made from split sheep-skins. Vellum is prepared from the skins of calves – *vealum* if you like. Goatskins are also procurable. The skin is first soaked in limed water to counteract the fats and grease, then stretched on a frame and scraped to the thinness required by means of a half-moon knife – a highly specialized skill best left to those who practise it as a livelihood.

As to the skins most suitable for scribes' use, the thinnest and rarest product, slunk, is an aborted-calf skin which is now no longer available in any quantity due to the greatly improved standards of husbandry and the consequent infrequency of premature casts. The best breeds of vellum-yielding cattle are the light-haired kinds – Guernseys, Jerseys, Herefords and Shorthorns – their skins being whiter than those of the darker-haired animals – Aberdeen Angus, Red Polls, Galways and Welsh

Blacks. The piebalds such as Friesians, Ayrshires and Shorthorn Crosses yield better vellum than the dark-haired animals but not as good as the fawn and light-brown stock. The younger the skin the less the fat, and the better the diet the better the vellum. In medieval times the animals were usually killed younger, due to lack of winter feed; although monastic farming, more efficient than most, may also have had the production of vellum for the scriptorium in mind. The thinness, opacity and suppleness of the best earlier vellum was doubtless due to smaller-sized beasts killed younger, and to the fact that their skins were selected more carefully for manuscript use and were prepared with a thoroughness and patience quite impossible under present manufacturing and marketing conditions.

The partly prepared skin is fixed down firmly by its edges onto the bench or onto a board, each side in turn, for a final dressing of the writing-surface to meet the scribe's requirements. These are, that the surface provide, first, a grip that enables stroke control and secondly, a trouble-free acceptance of the ink.

In the pen's relationship with working-surfaces, it needs something to bite on. A slippery writing-surface results in waste of energy and attention in struggling to control the formation of letters. A skin's properly-prepared surface can be gripped, leant upon, and dragged against rather in the manner of a drogue (a nautical term defined by the *OED* as 'a hooped canvas bag towed at the stern of a boat to

prevent it from broaching', that is, to assist directional control). Vellum (and parchment and paper) must be slip-proof. But, of course, the surface should never be so rough that definition is ragged. In an attempt to provide the pen with a better grip (and to increase flexibility), I once subjected parchment to sandblasting, but the cost and trouble, and the fact that dirty sand, infrequently changed, tends to tone down the skin to grey, discouraged further experiment.

For grip, a nap is raised by means of powdered pumice stone (pounce) rubbed vigorously with the flat of the hand in a circular motion evenly over the whole area of the skin. All surplus powder is removed on the completion of this treatment by either knocking the edge of the skin downwards against the bench or blowing it away drily, or by doing both. If done properly, the writing-surface will no longer be smooth and shiny, and will provide a satisfactory bite for the pen.

For the surface to meet the other requirement (that there be a trouble-free acceptance of the ink), a further, more sensitive rubbing with powdered gum sandarac is applied with the finger tips. This will not only help to prevent any tendency for the ink to run into the fibres of the skin, but will ensure a surface-tension in the ink that will enhance the sharpness of all thin strokes. However, if this is overdone, the ink may be unable to 'speak' and will jump back into the pen at the end of a stroke. In this event, surplus sandarac may be lightly wiped or flicked away with

a piece of silk or a cotton rag until the pen performs properly (if too much is removed, some can be put back).

The flesh side of vellum is not only different as a writing-surface from the hair side but demands gentler and more painstaking preparation of the kind described above. In some cases all that is needed is a rubbing with powdered sandarac; experience being the only sure guide.

In obtaining skins, a personal choice by the user from the maker is best. In selection from stock one looks for a combination of thinness, suppleness (Graily Hewitt used the West Country term 'suent') and opacity, this last being tested by pressing some black-and-white text against the back of the skin. The writing in a manuscript book may at times provide a shadow of itself through the vellum but this should not be allowed to confuse the top text itself. Thin leaves in a book reduce bulk. Suppleness allows the leaves to lie flat when the book is placed open upon the table (in this respect the smaller the page-size the greater the problem, so that large volumes may use heavier vellums). Nor should vellum (or parchment) leaves crackle self-consciously when turned. The material should accommodate itself to reasonable use readily and noiselessly, while retaining its shape. The softness of chamois, however, would hardly do.

Vellum and parchment are extremely sensitive to changes in humidity. Templates of the same material marked up for ruling purposes should

therefore be kept permanently with any sheets waiting to be ruled. The difference in airborne moisture between a rainy day and a dry sunny one can affect a twenty inch long template by as much as one eighth of an inch overall.

As there is an only too natural tendency for skins to curl up cylindrically with the hair side outwards, before use they need to be trained flat by keeping them for some time rolled on the opposite curl around a cardboard tube of generous diameter and inside a guard sheet of paper.

For vellums supplied 'trimmed to size' it is best to ask for one inch more on each dimension, since the frames used for the knife to follow round are not always rectangular and the angle of application of the knife itself has been known to vary considerably. Such pieces may be guillotined afterwards into accurate rectangles of the size required, or a carefully-measured cardboard 'shape' with corners at 90° may be pencilled onto the vellum which may then be carefully scissored up the middle of the lines. For single-sheet items, it may be best to estimate the margin generously, then complete the work, and trim when the framing or mounting is done. Such marginal areas are useful to test the pen upon or to try out some of the more complicated words upon as the work proceeds.

Vellums and parchments need handling in a manner which minimizes the risk of their creasing. One needs to develop a sensitive familiarity with the material, following its own scale and natural

movement. Accidents occur, however, and it is useful to know that modest creasing may be coaxed away in the following manner. The palm of the hand is placed underneath the creased area, with the crease itself in relief, upwards. Then with a smooth rounded edge such as that of a bone or ivory paper-knife, the bent fibres are pushed gently and firmly downwards into a 'reversed crease'. This being done, they will seek to spring back to their original level – a kind of compromise between two tendencies. It is a painstaking procedure and should be practised upon offcuts until understanding and confidence have been gained. The same treatment can be effective for paper. But in either case it should be remembered that even when restored the fibres have been disturbed and strained, and may prove absorbent to very thin inks. Thicker and more gummy inks will be less likely to penetrate such vulnerable places, and as much sandarac as the situation will stand should be employed over a corrected crease, which may then be included in the writing-area with every chance of success.

Parchment usually offers a harder, less tractable writing-surface than vellum. It is also whiter than vellum, which is mostly of a creamy colour. Goat-skin, tending towards a pale grey-brown and having considerable variation in thickness and surface texture, offers the pen a rougher ride, and is on the whole more suited to a larger-scale calligraphy than that for manuscript books. Parchment is a slightly more greasy material than vellum and so requires

extra surface care where definition and sharpness of stroke are at a premium.

All skins tend to be darkest on their outer or hair sides, and this is taken into consideration when planning the book, so that, in order that each opening or double-page spread is uniform in tone, traditionally, hair side is against hair side, flesh side against flesh side.

A skin cannot be tested for its quality in advance and its middle may perform very differently from its tested edges when taken into use, but experience and familiarity with the look of vellums and parchments will make for a reliable choice.

Paper, made from fibrous substances, is generally regarded as inferior to skin as a writing-material. But fine papers have a validity of their own. Its middle-Eastern forerunner, papyrus, is a long-lasting material, and we have documents made from it which are at least 5,000 years old. Papyrus is, however, soft and unsuited to quill pens, and even less suited to metal ones. Known to the ancient Chinese, paper seems to have been brought to Europe via Samarkand in the eighth century A.D., Damascus becoming a centre of its manufacture. It reached Spain and, by the thirteenth century, Italy, becoming available in sufficient quantities to make possible the sudden output of large numbers of printed books in fifteenth-century Europe, especially from Venice (though vellum was also printed upon).

Skins are extremely sensitive and vulnerable to heat and damp. Paper is less so, and it can satisfy the

requirements of many of the factors already discussed – consistency of appearance, surface, weight, opacity. It is also relatively inexpensive and available in standard sizes and in packs of standard quantities. Paper cannot of course compete with the subtleties of vellum and parchment, so lovingly nursed to the point of use, but properly used it provides a satisfying material to write upon. As to surface, somewhere between what is understood as 'hot press' and 'not' is acceptable, with a bias perhaps towards 'hot press' for gently dressing with sandarac. It should be pointed out that we have left behind the rather rigid notion that calligraphy must be in black upon a white material with its title or heading in red. Much may be accomplished upon papers of pale grey, fawn, sky-blue or Wedgwood green, in black or sepia, or inks of other colours. By the same token, white pigment mixed and used in the pen may be worked over dark-grey, brown, red, blue or green papers to excellent effect. I strongly recommend a range of papers in tasteful colours still made by the Montgolfier Brothers of Annonay, France, called 'Papiers Canson' – 'Mi-Teintes'. These facilitate the crispest of pen strokes. However, they are hardly thin enough for manuscript-book leaves: 'Ingres' papers made by the same company or 'Fabriano' (an Italian paper) might well be preferred for books.

Vellums, parchments and papers do not always lie perfectly flat upon the writing-board. Frequently, the pen when set down to begin a stroke will make

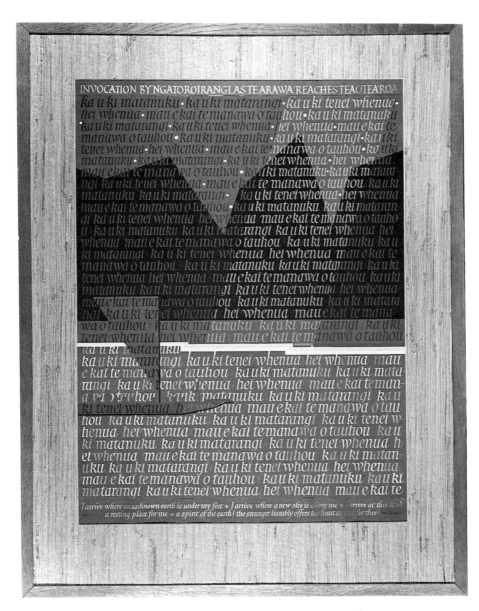

"Te Arawa Reaches Te Aotearoa". A prayer by Ngatoroirangi at the end of the tribe's almost three thousand mile navigation from Kahiki.

Dimensions inside mount, 54 cms wide x 72 cms high, framed in square sectioned oak. Laid Papiers Canson – sky and sea of Dark Blue (500), the Volcanoes Tongariro, Ruapehu and Ngauruhoe silhouetted in Black (425), the forest behind the beaches Ivy (448), and the red sailed canoe Burgundy (503). This Maori prayer of six phrases (English translation below in gold) is repeated over the whole area, in painted letters from double-pencil-work. Against the sky, each phrase is followed by a small star, and each completed prayer by a larger one, producing a random constellation. The supernatural beam of light, invoked by Ngatoroirangi as the great canoe slips through the shoaling waters towards the beach at dusk, is effected by lightening the tone of the relevant wording, while the breaking of the surf is indicated by repeatedly raising the tone of letters from grey to foam-white. William Gardner, 1968.

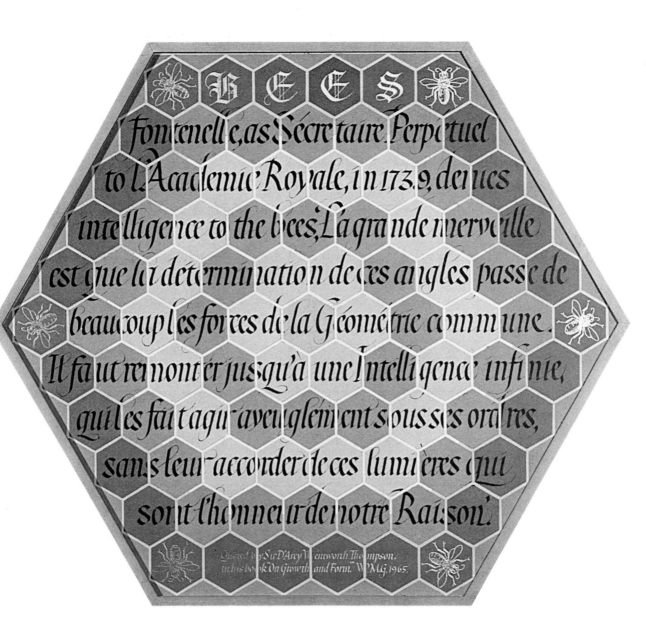

"Bees". Fontenelle quoted.
Cut from a 1¾" patchwork metal template, a laid assembly of Papiers Canson. Inwards – Biscuit (502), Buff (384), Oyster (340), Buff (384), Oyster (340), and pale Lime Green. The frame is of square section wood painted the colour of wax and measures inside 54 cms from angle to angle. The hexagonal papers were assembled close for writing upon, but released and distanced up to 3 mm apart, to reveal a wax coloured background simulating the walls of cells. Further distancing proved unacceptably disruptive to the text. The title and bees are in gold. William Gardner, 1965.

initial contact with some area of convexity in the writing-material and proceed to push the sheet downwards against the board, upsetting the stroke's beginning. Being springy, the writing-material will tend to resume its position as the pen lifts at the end of the stroke, sometimes in this way spoiling the crispness so much desired of both beginnings and endings. The solution is to hold down the writing-surface in the area immediately to be written upon against the board while the strokes are accomplished. This is done with a small piece of thin bamboo cane, a piece of dowelling, or the shaft of a water-colour brush (or with whatever else may be found convenient), held in the hand not using the pen. Traditionally, it was the pen-knife so constantly in use to mend the point of the quill. It is this that is seen being used in depictions of Evangelist scribes at work in medieval manuscripts. An example is illustrated here (from a Gospel Lectionary (Hereford?), the University Library, Cambridge, MS. 302, f.88v), showing St John at work upon his Gospel, pen in his right hand and attendant pen-knife in his left (Plate 6).

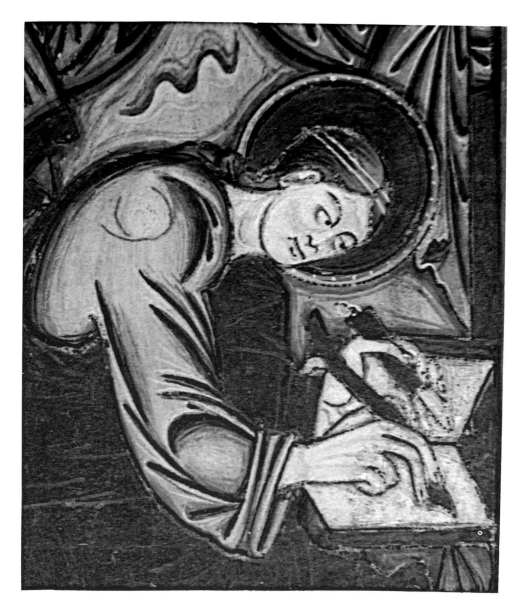

Plate 6: St. John writesfrom a Gospel Lectionary (Hereford?), University Library, Cambridge, MS 302, f. 88 v, showing St. John at work upon his Gospel, pen in his right hand and attendant penknife in left.

Ruling

From the time of the stone inscriptions of Imperial Rome guide-lines have been used for the alignment of letters. This has been so whether the letters were painted, engraved, drawn or written. Such lines were either removed, like scaffolding, upon the completion of a work, or frankly retained as part of the structure.

(334)

In medieval times, four vellum sheets – a *quaternian* (334) – were pricked and folded together to form a section of eight leaves or sixteen pages and in early codex form were often ruled blind with a smooth, hard point, indentation on the one side providing lines in relief on the other. Ruling was also accomplished by means of a plumbago (lead) point (or plummet), or with a pointed pen and using unobtrusively thin ink. Nowadays, the plummet's successor, the lead (graphite) pencil, is widely used. Whichever instrument was employed for ruling guide-lines, the scribe rarely if ever wrote upon them, but steadily between, touching neither. While there is nothing against using ruled lines for guidance in this way today, I write touching pairs of lines of minim height apart, with sufficient distance between the pairs to avoid any clash between ascending and descending strokes of the script being employed. In cases where this distance is less,

descenders may be delayed, as has been mentioned, until the demands of ascenders in the following line are known; but this might well be considered squeamish – better to act instinctively according to situations as they arise.

In penmanship, the prevailing tradition is to rule guide-lines by means of a T-square sliding against the left edge of the writing-board, the points at which they areto be ruled being marked by a sequence of holes pricked equidistantly either by walking a pair of dividers down the left edge of the writing-material, or from a template of the same meterial as that to be written on. Similar means are used to establish vertical lines for side margins, and these form the limits between which the guide-lines are ruled. Frequently these holes remain, but in many cases they are trimmed away during the binding of the manuscript.

It is of interest that only in comparatively few instances do we see unbound leaves being written upon for assembly into books of codex form. Most of the Anglo–Saxon and Romanesque Gospel paintings show the Evangelists writing into already-bound books of ruled, blank leaves – much as entries are made into ledgers. However, the book-binders will explain that without exception, vellum or parchment leaves of books were already written on and decorated before being folded, gathered, sewn together and covered with boards, and we must assume that the great majority of examples illustrated otherwise simply signify that Holy Writ is

pre-ordained and complete.

Having pricked the holes, a very sharp pencil-point of medium hard grade is pushed into the lowest. The T-square is then moved gently up the edge of the board until it touches the pencil point. It is then clamped firmly into that position with the left hand. The pencil is then used to rule a line along the T-square's upper edge between the prescribed vertical lines. For pages already pricked (or marked, marking being the alternative to pricking holes), it is far easier to rule the lines in a rising sequence from the bottom of the sheet, coming up each time to the placed pencil-point (or mark) instead of sliding the T-square downwards and then having to bring it upwards to the pencil (or mark) again for the start of each line. An incidental point to note is that T-squares, and indeed other pieces of equipment, ride more happily over flat adhesive-tape than over drawing-pin heads. To avoid using pins when securing writing-materials for ruling, adhesive tape (Scotch or Sellotape – even masking tape), which is readily removed from vellum and parchment when pulled slowly and patiently, may be used instead. In the case of softer materials such as paper it is advisable to peel the tape off lengthways, slowly and at a very low angle of tension (335) so as to avoid disturbing the surface fibres during removal.

(335)

(336)

(337) (338)

If guide-line intervals are marked in pencil, even greater care is needed to ensure that the pencil, when ruling, commences in the right place every time a line is drawn (336). However accurately such marking is done, carelessness in using it can spoil a line of writing to a much greater extent than might be imagined. If the ruled lines from the first pair of such marks, for example, happen to run outside (337) and those from the second pair run inside (338), a difference in size will be noticeable between the two lines of writing concerned. If the utmost care is not taken in this respect the text itself may well lapse into an overall inconsistency.

In ruling, whatever method of marking is used, not only should the internal angle of the T-square be set truly at 90° and its working-edge be absolutely straight, there are further factors that need watching. Any slight convexity of the T-square head is likely to cause it to rock against the edge of the board, making for uncertainty in the ruling action (339). Even the truest head may well produce converging or fan-like lines if moved along a board-edge which is itself convex (340) or concave (341). With both T-square and board untrustworthy, ruling and therefore the appearance of a written text which follows it is certain to be at risk (342). By the same

(339)

(340)

(341)

(342)

(343)

token, if the working-edge of a T-square is arched, or sags, the lines of writing will reflect the fact in no uncertain manner. Should the working-edge be warped away from the writing-surface any ruling against it would need to be done with the pencil vertical if distortion is to be avoided (343). In fact, only when everything has been checked and found to be in order is effective ruling possible. Even dents and scoops out of a T-square's working-edge may affect writing by 'ducking' it at the same place in each line of the page. Of course, the parallel gadgetry of a drafting-table might serve to overcome all this or most of it, though perhaps at the price of over-mechanization.

The ruling-pencil will need frequent re-sharpening. A good pencil-sharpener with a new blade will do, but a very sharp knife used with care is likely to be better. Remembering that a soft graphite point can wear down rapidly, even between the beginning and end of one ruled line, a medium or hard grade (HB or H) is recommended. For an exceptionally lengthy project, a very hard grade may be appropriate. For instance, for the seven volumes of the Household Cavalry and Foot Guards 1939-1945 regimental Rolls of Honour, the 9H pencil used provided over two-and-a-quarter miles of guide-lines on vellum.

Beware of T-square, set-square or straight edge which has no bevel away from the writing-surface. Lines ruled in ink or water-colour may creep under the edge of such an instrument and leave a smudge.

Makeshift instruments

While the dividers for pacing out the ruling-marks should be of the kind which can be locked to a measure by means of a threaded rod and knurled wheel, for these are obviously more reliable in use than those which rely on the friction of a hinged joint alone, two fine pencil-marks at the edge of a piece of paper may serve as dividers in an emergency. Similarly, a compass may be contrived from a strip of paper or thin card with one end turning on a pin, and a pencil-point thrust through the other end at the desired radius. With the pencil held vertically and gently tensioned, a perfect circle may be inscribed. Even a pencil held between thumb and forefinger can with practice yield a very acceptable circle if the sheet is small enough to be rotated under the knuckle of the little finger of the same hand. A set-square may be contrived in an emergency from a sheet of paper having a straight edge (or for that matter a fold which is straight). When folded so that two parts of the straight edge align the fold will subtend 90°; and a further fold made carefully should yield 45°. These and countless other contrivances must have been brought into play by medieval scribes during the course of their work. Unable as they were to visit an artist's colourman round the corner for pens, pencils

and brushes of every size, bottles of ink and so many other requisites, their achievements seem all the more miraculous. Nor were optical aids such as spectacles or the magnifying glass available until the end of the middle ages.

Pens, inks and pigments

Trimmed feathers (*penna*) have been employed for writing upon the prepared skins of animals since the use of papyrus diminished in the fourth century A.D. The suitability of swan, goose, and sometimes crow feathers as writing instruments remains unquestioned. Turkeys were more common in Europe following the Spanish conquest of Mexico, and it is thought their feathers were taken into use generally in England from about the middle of the sixteenth century.

Quill pens reach today's scribe partly prepared by the manufacturers. They are then stripped by the scribe of their barbs and shortened to approximately the length of today's pencil – seven inches – a length convenient for the human hand. I have assumed here that the final dressing of a quill for writing purposes, from the first long slice into the barrel, through the scooping out of the shoulders, the slitting of the nib, the flattening of the inside of the barrel, the cutting of the pen's working-edge at a slightly oblique angle, to its completion with a final meticulous chop, has already been mastered (Plate 7). The detailed procedure for preparing quill pens has been most carefully described by Edward Johnston and illustrated by Noel Rooke in *Writing, & Illuminating, & Lettering,* and has been further

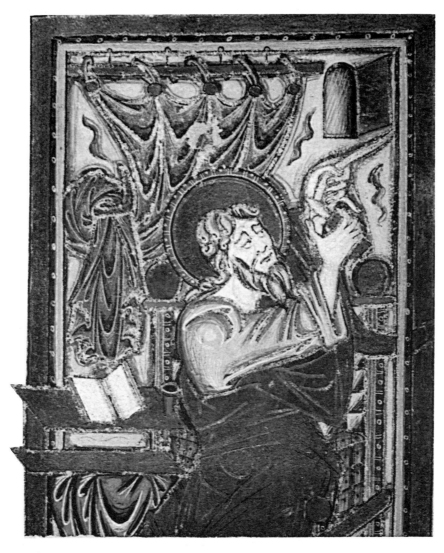

Plate 7: A depiction of St. Mark, trimming his quill with a pen-knife. Gospel Lectionary of c. 1050. Hereford? (University Library, Cambridge, MS 302, f 38.)

discussed in the writings of his followers – Graily Hewitt, Dorothy Mahoney, and others. Two reminders only may be added. By cutting its working-edge at an angle of some 15° from the square the pen may be maintained in the hand very comfortably and effectively without the strain of pulling the elbow inwards towards the body which a square-ended instrument would demand to secure a correct writing-angle. And secondly, the slitting should not be overdone or the pen will be too flexible, and tiresome to control. Even modest downward pressure on a too deeply slit pen is likely to increase stem-width unduly. And, although letters in Western manuscripts (other than those in copperplate) are formed only through changes in the *direction* of their stems, control of stem-width is of vital importance.

In the great majority of early depictions of the Evangelists at work, the pen-knife is shown as a short blade not unlike a scalpel mounted upon a shaft, with a total length of about seven inches. (Michael Gullick has even drawn attention to a runciple or saw-edged one – in a manuscript dated 1170.) The blade of the pen-knife used in preparing quills must be set and sharpened on the outside (344) since only in this way is a curved paring action possible in the quill-cutting procedure. The shoulders of the pen are in fact scooped out with the help of leverage from this bevel, and a knife of any other section cannot operate properly.

There can be no question that a well-trimmed

(344)

quill pen, sensitively handled upon suitably prepared and dressed vellum produces scripts of greater sharpness and subtlety than could be produced by any metal nib, though I have found that some metal pens closely approach the quill pen in sensitivity and comfort of action. Of course, metal nibs may be sharpened further upon a fine oil stone (one must avoid allowing the oil to approach the ink), but this can prove self-defeating in that the corners of an over-sharp metal working-edge can catch in the writing-surface, hindering the letter-making and in extreme cases causing ink splutters. A well-cut quill acts crisply enough and poses no such problem.

Maintenance of pens is essential. A metal nib may rust or corrode and a quill is to some extent absorbent and so may swell. After each stint of work, pens should be wiped dry with a rag which will not leave short fibres to be introduced into the ink at the pen's next filling – a serious risk since they may jump the inside of a curved stroke or an angle, spoiling the work by taking ink with them. Obviously, finely-spun material closely woven and therefore non-whiskery is best – linen certainly, cotton possibly. Silk will not, however, soak up ink readily, and paper tissues, while absorbent, tend to shed their fibres disastrously.

As we know, filling a pen by dipping it (in spite of medieval depictions) wraps up the working-edge with ink all round in such a way that very sharp strokes are more difficult to achieve (345). The only

(345)

satisfactory way to fill or refill a pen is to turn it onto its back and introduce drops of ink into the barrel and reservoir from the end of a small rod of wood, an old water-colour brush, or, perhaps, a knitting needle. In this way the ink will reach the writing-surface more sharply, from the under-edge of the pen only (346).

(346)

filling the Nib from a brush (the brush standing in the inkpot on the left & then fixing done with the left hand so as not to disturb the pen hand) is a much more regular method than dipping.

There are two choices of inks. *Encaustum* (blue-black) is produced to ancient recipes from crushed oak galls and copper-sulphate crystals brewed up in water, bound with a small quantity of gum-arabic, then strained off through muslin. *Carbon ink* is powdered lamp-black mixed with gum. It is sometimes supplied cast into sticks of an oval or hexagonal section (347) for grinding with water to the consistency required on a palette by hand. Since grinding by hand cannot be hurried, I have employed a twist-drill chuck specially made to take stick ink. More usually it is bought ready-made, in bottles.

(347)

The working density of writing-ink, whether encaustum or carbon is an important matter to the scribe. Some would claim that carbon ink provides

the best answer to today's needs, even in the form of the manufacturer's bottled product. Calligraphically this may be true, but what of its future as a permanent record? Encaustum burns into the writing-surface to a considerable degree and has been used for millennia. The more readily erased stick inks though tenacious remain at surface level only.

Inks should generally avoid being too watery. A watery ink not only lets its suspended pigment sink down to the bottom of minims and strokes written on a slope, leaving their tops markedly anaemic, but also allows the double deposit to be clearly seen where stems cross or merge, as in Edward Johnston's blackletter alphabet (see pp.44, 45). The visibility of double deposits is helpful in a demonstration alphabet, for it reveals the anatomy of things, but it is a disruptive element in a page of finished work in the vertically uneven distribution of pigment.

Where colour is to be applied to a white surface, it is not as a rule coloured inks that are made use of, but such water-colour pigments as vermilion for red, oxide of chromium for green and cerulean or azurite for blue, suspended in water into which a little gum-arabic has been stirred to provide a degree of sparkle when dry. The technical exercise is to balance opacity with fluidity towards a good pen-flow.

Interruptions to word-flow should be minimized by taking on as much ink as the pen and reservoir will safely hold. It is a matter for experiment, but the refilling should be carried out some time before the

pen runs dry so as to avoid unevenness, especially in manuscripts written with thin inks. The larger the writing the more frequently will the pen need recharging. It is of interest to see Edward Johnston's own diagrams of reservoirs in a letter of 30 August 1918:

Correction and erasure

Edward Johnston's attitude to the truth required a frank correction or an insertion of text using crossings out and carets. Others hold that such actions deface the page unnecessarily. Successful erasure is feasible – dependent of course upon infinite care and patience. However scrupulous a scribe may be, and however vigilant, accidents occur through fatigue or distraction: a word may be misspelled, repeated, or even omitted altogether . More serious still, a whole line may be accidentally omitted (homoioteleuton, see p.169) – a disaster possibly involving the rewriting of a page, or even several pages should the mistake not be noticed soon enough. Such a catastrophe may be avoided by exposing the copy only one line at a time, which can readily be done by means of a piece of thin card with a window cut in it the size of one line of the copy. A window cut to show three lines of copy enables one to check on the line just completed, copy the middle line and preview the next. Such masks, held to the page margin with a small bulldog-clip or secured in some other way, are moved downwards as required without preventing examination of the page as a whole.

A careful consideration of the physical aspects of a written mistake may well decide in favour of an

erasure, the cost of vellum and, possibly, the need to redo other good work being major factors to be taken account of in making the decision. If one letter only is to be changed for another, for example **e** for **c**, **u** for **n**, or **b** for **p**, or if some other simple alteration is required, there should be no difficulty. In the case of **e** being replaced by **c**, the tucked-in part of **e**'s second stroke must be removed and what is left given the '**c**-head' treatment. To change **u** to **n**, the upper part of letter **u**'s first stroke must be retained and used towards the first stroke of **n**, **n**'s second stroke being made from the useful part of **u**'s second. The replacement of **b** with **p** requires the removal of **b**'s ascender, and the addition of a descender from the lobe common to both letters. Keep a piece of best quality blotting paper handy; a quickly blotted residue, when dry, is much more easily erased than any thick deposit of dried ink or colour. To rub or scrape at whatever is unwanted while it is still wet is naturally to court disaster. Before beginning any erasure it is advisable to press the letter or word concerned with a piece of paper to confirm that there is no offset from damp ink, even if it has been left overnight.

Erasures may be made with a very sharp scalpel or quill-cutting knife. The exercise is literally to shave away the writing-surface with the written error without disturbing the rest. Any roughnesses are then burnished down for the reception of sandarac and the correction itself. Should the erasures be small – such as a speckle of ink – the point of a very

sharp blade will prove excellent for the job. All should preferably be done under powerful magnification. Confidence grows with experience, and eventually the ability to alter even lengthy words undetected becomes a comfort in reserve for the practitioner.

Speed

Professionally, of course, scribes can put on a spurt if necessary, and speed is something that will vary between styles of penmanship and their executants. There is a limit to the speed of performance with, say, square capitals, but italic cursive hand can be whipped along at an astounding rate, faster it has been claimed than other kinds of handwriting, because of its inherent 'time and motion' qualities. To rush formal scripts, however, is to risk error and lose finesse. The pen imposes its own speed upon its user, who will wisely balance urgency with what can be performed well, and this in turn will be affected by pauses to check the text and to refill the pen, along with other physical aspects already discussed. We have touched on the speed of flourishes and the need to avoid unsteadiness, and the same applies to the formation of the stems and strokes of majuscule and minuscule scripts. Where any flourish or stroke appears to proceed erratically it will be because confidence and navigational judgement, that is, the ability to make changes of course smoothly and in due time, are lacking. Hesitation risks panic, causing directional changes to be made too late and too sharply – for example, producing a series of 'facets' for a letter **o** (348), rather than flawless curvature towards

(348)

well-anticipated meeting places.

At the time of the rebinding of the Domesday Book in 1952 (see *Domesday Rebound*) the Public Record Office sought the help of the scribe Alfred Fairbank to discover by practical test the speed at which its bookhand could have been performed, and thereby to discover whether one or more clerks could have inscribed a fair copy between the dates given in the Anglo-Saxon Chronicle – that is, between Christmas 1085 and Michaelmas 1086 (eight months or 240 days). Fairbank's experiment gave an acceptable speed for a scribe of a page and a half, or six columns, a day. According to Dr Helen Forde's account of the 1985-6 rebinding (*Domesday Preserved*), the scribe Michael Gullick, after further experiment, came to the same conclusion.

Scale of work

The scale of work at which scribes (whose hands vary in size comparatively little) perform best is with the minims of minuscules at about a quarter of an inch high. At larger or smaller sizes a compensatory increase in control is required. The required control at sizes of, say, half an inch or more is less easy to attain, while penmanship at sizes smaller than a quarter of an inch, at, say, one sixteenth of an inch or less, as in some of the thirteenth-century manuscript bibles, is considerably more difficult. At the smaller sizes the necessary distinction between thick and thin strokes tends to be lost. Two illuminated manuscript books in the library of the Queen's Doll's House at Windsor Castle demonstrate the point. The two scribes concerned, Graily Hewitt and Doris M. Lee, patently found minuscule hands with minims approximately one millimetre high difficult to manage. Edward Johnston might have done better, but I personally know of no such diminutive writing by him.

An example of medieval micro-writing may be found in the left-hand margin of folio 259 verso of the mid-fourteenth century Missal of St Denis, now in the Victoria and Albert Museum Library (MS. L. 1346 – 1891). Within a circle slightly less than the size of a modern one penny piece are written, in a

somewhat strained and widely-spaced blackletter
minuscule hand (together with a number of versal
initials) eighty-nine words (twenty-five lines) of the
Magnificat. The texture is remarkably even, but
letter form proves hard indeed to achieve at this size
(349).

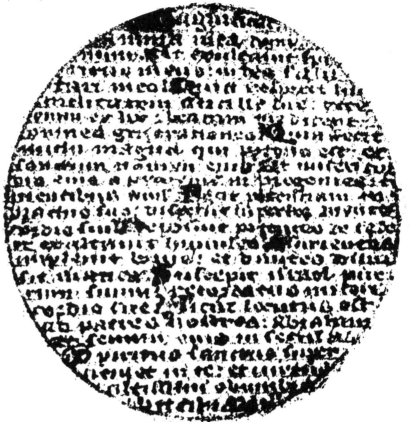

(349)

Part IV: CONDITIONS OF PRACTICE

It would be wrong to omit certain other considerations which bear upon efficiency at the writing-board.

Fatigue

Undue physical exhaustion is likely to defeat proper control of the hand. An extreme example may be seen in exhibited collections at the Public Record Office, where the handwriting of Guy Fawkes shows a marked deterioration after torture. But one need not take such a traumatic case – a stint of digging in heavy clay or a ten-mile jog may well render calligraphy as such unattainable until the following day. Even then things may not be sufficiently tranquil for fine penmanship, as Johnston himself

My hand is shakey this morning (the result of carrying my youngest daughter for a climb yesterday)

once found: Alfred Fairbank stressed that relaxation is an essential factor in the production of fine penmanship. And Cennino Cennini would have been the first to welcome the several mild, non-addictive tranquillizing drugs available to modern calligraphers.

Stage fright

Exacting calligraphy is frequently accompanied by a kind of panic, especially noticeable in the important penmanship of a first line. To commence with the second line, having carefully assessed the first, gaining confidence during lines two and three and then whipping back to ensure a controlled beginning, is one way of overcoming such reluctance.

Temperature

Temperature is another consideration. Romantic though the notion might seem of monastic scribes cloistered in the freezing draughts of a medieval winter, a moment's thought will serve to reject such an idea. Scribes with blue hands and virtually stationary circulations could never have created the master scripts we so much admire today, and whatever relief was then available we may be sure was very gratefully taken. Scriptoria would be at least sheltered, and with fine penmanship the goal, scribes must have received dispensation to warm their hands either in the monastic kitchens or in the calefactorium. In these days we should not expect sustained worthwhile calligraphy at much below 5°C.

Noise

As to noise, the sound of traffic and aircraft may perhaps have to be suffered, but avoidable disturbances, however slight – the warning whine of a senile electric light bulb or the persistent rattle of a door or window – are best run to earth and eliminated without delay. It is wise to seek out systematically and suppress anything which may distract. We have already mentioned the work-bench with unsteady legs and the resulting rolling about and knocking together of instruments. As to interruptions, a notice with such words as 'ON NO ACCOUNT DISTURB' should be attached to the outside of the workroom door. Inside, a trappist silence is conducive to efficiency, and helps to secure the tranquillity necessary for lengthy and crucial passages of writing, to avoid misspellings, omissions and repetitions, and to permit that total concentration needed to bring about exacting work upon the page. It is of course possible to be preoccupied to the point of jumping violently if the door is opened suddenly. Lock it. The telephone may ring in one's ear startlingly enough to cause one to spill the ink out of the pen or to inscribe some important stroke in a jerky manner. My own telephone has been doctored, and now provides only a very gentle alert, just audible in the silence. A

telephone answering machine placed elsewhere might well serve better.

NOISE 155

Breathing and ventilation

Mental tension may at times be high during calligraphic work, and partial retention of the breath needs to be watched. It is true that to hold the breath for a few moments may well provide a way of preventing movement which might spoil the 'follow through' of some elegant pen-flourish or vital sequence of strokes, but sustained breath-holding is to be avoided. Lethargy can result, and a hazy relationship between eye, mind and hand is likely to produce slurred work. Whatever the cause, should things begin to go badly, experience dictates a pause, if necessary overnight. By the same token, if the work seems to be going dramatically well, the most of such an opportunity must be made, even continuing all night if the writing is speeding along on an extra-favourable tide.

That the workroom should have proper ventilation goes almost without saying. I have found the solution to be an extractor fan, set high in the wall at one end of the room, and complemented by a similar-sized opening at the other end. The fan, which is draught-proof against high winds, is of large diameter for slow, noiseless running, yet has three speeds each for intake and extraction. An external grid to each aperture has a turn-down top to its slanting louvres which allows free passage of air

but denies access to rain. These grids are lined with fine copper gauze, blissfully excluding most insects.

Lighting and eye-strain

Lighting is another important consideration. There seems little doubt that the best early manuscript work would have ceased at dusk to be resumed at first light. For those who have tried it, light from candle or oil-lamp can be a juddery business, especially where draughts prevail. The eyes need a steady and adequate source of light to distinguish the stems of letters from their background. Optical aids were not available to the early scribes, and sight must have been of short focus to achieve some of the exquisitely minute hands of many of the books of private devotion.

Liturgical manuscripts did not generally suffer the risk of fading. Candlelight would be the most to which the written vellum pages would be exposed after dark. Early church windows provided the filtered protection of stained and painted glass by day. Moreover, when not in use such manuscripts were kept closed by means of clasps and put away in cupboards.

The present-day calligrapher requires an unwavering but not too brilliant source of light, shaded from the eyes and falling in such a way that the writing-board itself does not directly reflect a glare. Since penmanship is traditionally a right-handed technique the source, whether from ceiling

light, desk lamp or, during the day, window, will need to be positioned somewhat ahead and to the left of the work so as to avoid shadow from the hand.

It is arguable whether light is best as a point source, or diffused. I personally find that the action is assessed and controlled better where everything involved casts something of a shadow. If one is working in a studio with a sky-light, however, diffused glass will prevent the shadows of mullions marching relentlessly across the working-area on sunny days.

Warm, yellow-hued, artificial light is cosier than a cold, blue one, and although so-called 'daylight' strip lighting is also available in my workroom it is the warmer, yellower lighting which I use more frequently.

In concentrating upon very lengthy manuscript works, eye-strain is not unknown, and I have found that the ophthalmic surgeons' operating glasses known as the 'Bishop Harman Spectacle Loupe' are a help for any small-scale work. The magnification is at a convenient two-and-a-half times or thereabouts, and focus is not too close to the writing to hinder one's work. Because the twin lenses are angled prismatically slightly inwards so as to permit the two lines of sight to function in parallel, the eye-strain caused by the squint required to squeeze binocular sight through a single lens is avoided. Sight itself is not, of course, corrected in this way, but the Loupe may be used in conjunction with one's ordinary spectacles.

Part V: OTHER MATTERS

Calligraphy and graphics

Penmanship for graphics demands a different attitude from that of the book scribe. With manuscript books the aim must be: (1) an accurate text, (2) ease of reading – that is, style subordinated to legibility – and (3) a controlled elegance. With graphics a degree of extroversion – even of abandon – quite inappropriate to bookwork may at times be allowed (322) (323). The difference is broadly between what typographers distinguish as text faces and display faces. With display, the end justifies the means, and if scribes are commissioned for advertising, packaging and book jackets they may obviously show their paces. Such work allows the use of many different kinds of procedures. If a very small script is required it may be reduced photographically from work done at a scale convenient for the scribe – provided always that he knows what happens visually during photo-reduction, and makes due allowance for it. By the same token, photo-enlargement is possible. Amalgamations and paste-ups, involving much ingenuity and skill, are often called for.

If a pen style with sheered-off feet is needed, stems and minims may be taken down below and then cut off at the base-line with white photoproof fluid or by means of a strip of white paper. Palaeographers

might admit the result to be a modern version of the medieval blackletter variant Precissus Sine Pedibus (350).

anima mea domino

(350)

Where the meticulous slanting of italic or indeed a reliable uprightness for basic script is required, a curtain of soft pencil lines, not for writing against but for sighting the strokes, may be spread at irregular intervals across the sheet – a scaffolding removable on completion of the work. Alternatively, if the work sheet is sufficiently translucent, a heavy grid placed underneath it can serve the same purpose. The experienced practitioner, however, will not need such aids.

Calligraphy and typefaces : verve

A type face – unlike a script, which is 'live' in the sense that no two strokes are ever precisely the same – however elegant and however much it attempts to render faithfully a style of writing, will by the repetition of identically-formed strokes make the appearance of the text to that extent 'dead'. However consistent the penmanship in manuscript work, there will be a subtle and continuous variation in letter formation, and it is that that gives it its particular visual life. Although there have been examples of that form of animation in type faces – for instance, unconsciously in Alfred Fairbank's condensed italic ('Narrow Bembo') of 1928 and consciously in Herman Zapf's Noris Script – whatever 'touches' may be given to individual characters to give them verve are echoed mechanically throughout the text. Loss of verve is unavoidable.

The reproduction of calligraphy

How may calligraphy be multiplied mechanically without losing those qualities that give it verve? Since printed texts may now be assembled photographically from a stream of characters in negative, light projected through a film matrix could readily assemble pen made letters strung together in this way, their stem terminations each designed to overlap slightly the following stem 'just like the real thing'. However, the repetition of such pen-formed characters throughout a text would kill it stone dead. As a refinement one might consider a film fount which incorporated variations of a proportion of such a script alphabet, and a rotational use of such variables might well lend a semblance of animation to the page. Yet it seems unlikely that system designers would find any profit in such a notion.

We are left with the option of a straight photo-litho offset reproduction of original penmanship (351). In controlled style, an italic script, reduced photographically by the page to book sizes, is likely to come close in general appearance to, for example, Bembo italic type face set at that size, but the presentation would be 'alive' for the reason discussed in the previous section. The thinning of thin strokes would need watching since very substantial reductions in scale risk losses in the

Dangers of gambling with Love

Cupid and my Campaſpe playd
At Cardes for kiſſes, Cupid payd;
He ſtakes his Quiver, Bow & Arrows,
His Mother's doves & teeme of ſparrows;
Looſes them too, then downe he throwes
The corrall of his lippe, the roſe
Growing on's cheek (but none knows how),
With these, the criſtall of his Brow,
And then the dimple of his chinne:
All these did my Campaſpe winne.
At laſt, hee ſet her both his eyes;
Shee won, and Cupid blind did riſe.
O Love! has ſhee done this to Thee?
What ſhall (Alas!) become of mee?

John Lyly c. 1554–1606

(351)

reproductive process, and some practical compromise would be necessary.

In spite of an understandable fear by poet or by author of extrovert calligraphy coming between himself and his public, readers of verse rendered in suitable calligraphy have confessed to an added dimension of enjoyment.

And a recent correspondent finds that 'the written word had become a recitation; not words waiting on a page to be peeled off by the reader but words uttered.'

Calligraphy and palaeography

Palaeography is the art or science of deciphering ancient inscriptions or manuscripts. It observes scribal practices and codes of calligraphy in association with identified schools of script, as well as their transmission of and influence upon specific classical and liturgical texts. Palaeographers' textual criticisms have provided analyses of medieval scribes' sins of commission and omission – sins such as *Transposition* (copying words or letters out of place or in the wrong order); *Dittography* (writing words or letters twice); *Haplography* (writing words or letters only once when they should have been written twice); and *Homoioteleuton* (such as, the omission of a whole line having the same ending as the previous one). Knowledge of these analyses facilitates the scribe's avoidance of the copying errors to which the practice of calligraphy is said to give rise. That present-day scribes can benefit from palaeographical criticism is due to the similarity of medieval and modern practice, and this very similarity enables assertions about early scribal behaviour to be checked. For example, it has been advanced with regard to punctuation that medieval scribes may have been given to resting their pen points on the writing-surface while checking the copy. But, as that is something totally

uncharacteristic of professional behaviour – the good scribe instinctively avoids extraneous pen marks of any kind and has little difficulty in finding again the last word written – it may be doubted whether the medieval scribe was in fact given to doing so.

Handwriting

It is of interest that before the fifteenth century few made personal use of what we now term handwriting. What could well be the writing of that great translator and England's first printer William Caxton is in the custody of the Pepys Library, Magdalene College, Cambridge – nearly a quarter of a million words of his translation into English of Ovid's Metamorphoses. One can feel the heartfelt cry from the prologue of one of his other lengthy translations, the *Recuyell of the Histories of Troy*. (1471) 'my pen is worn, mine hand weary and not steadfast', given as every good reason for his adopting the recent mechanization of scripts called printing. How he would have blessed the typewriter and word-processor! Yet with eyes dimmed from the reading of today's relentless outpouring of printed matter, a similar sudden cry might go up for the

comfort of handwriting – for a taste of the real thing.

Handwriting must be readable and will obviously be of greater value if it is also pleasant to look at. So legibility and elegance are the qualities to be looked for in a hand that is to serve as a model. What better than to seek out the work of the fifteenth- and sixteenth-century masters, whose exemplars and copy-books contain elegant and speedy handwriting styles, which are also readily acquired and economical of writing materials? Besides, there is something so undeniably romantic about the names of Italian Renaissance writing masters and practitioners – Felice Feliciano, Giovanantonio Tagliente, Fausto Capodiferro, Gianfrancesco Cresci, Niccolò Niccoli, Poggio Bracciolini – that the notion of italic handwriting is almost irresistible. However, for those who are not spell-bound by the italic theme, and for those who fear that the italic hand must inevitably suppress personality in writing, the following set of procedures is offered as a method of redeeming and refining existing mature hands of other kinds without the totally metamorphic jump into italic.

1. Practise your normal handwriting in slow motion with the letters and words more evenly spaced.
2. Do the same but with the strokes and minims of uniform height.
3. Give attention additionally to the regularity of ascenders and descenders.
4. Concentrate on the consistency of whatever slant your particular style may happen to have.

5. Improve capital letters one at a time from some good model. Do the same for the minuscule letters, and for the arabic numerals.

6. Procedures 1 to 5 having been practised separately, and in stages, all may now be amalgamated into one improved hand. At this point also, a reasonable speed may be developed; but not at the sacrifice of gains made in other directions.

Finally, it may be noted that if the pen used has a narrow, square-ended or right-obliqued nib, and if its working-edge is kept at about 30° from the horizontal, the improved writing may well tend to resemble italic.

Bibliography

Possession by a scribe of most of his essential reference books — even in the state that an antiquarian bookseller would describe as that of 'working copies' — is a worthwhile aim, and to work or live near a good public library is a boon. Through the central library system access can be had to most of the titles listed in the select bibliography that follows. Yet other, rarer, books are retained in the national collections.

No practitioner of advanced calligraphy will be content in not possessing large-scale (actual size at least) facsimiles of the main influential scripts of post-Roman Europe — square capitals; rustic capitals; versals; uncials; half-uncials; the true minuscules of Ireland and England, France, Italy, Germany, the Low Countries, Iberia and Scandinavia; all blackletter hands of the fifteenth century; and the hands of the late-nineteenth-century revivers, Morris, Johnston, Fairbank and others. The scribe cannot have too much studio or workshop reference or too much sight of the originals: the batteries need frequent recharging.

Association Typographique Internationale. *Dossier A – Z 73.*
Full account of a provocative conference at Copenhagen in 1973 on the theme 'Writing is dead! Long live writing!'

Backhouse, Janet. *The Lindisfarne Gospels.* Phaidon, 1981.
A well-illustrated work on the famous English manuscript.

Bishop, T.M.A. *English Caroline Minuscule.* Oxford, 1971.
A fully illustrated account of the development of this English bookhand.

Baltimore Museum of Art. *2,000 years of Calligraphy.*
Comprehensive illustrated catalogue of the 1956 exhibition.

Blunt, Wilfrid. *Sweet Roman Hand.* James Barry, London, 1952.
A short, well-illustrated account of the development of italic handwriting from its beginning.

British Museum. *Catalogue of Books Printed in the XVth Century now in the British Museum.* 10 vols., 1908 (reprinted 1963–).
Indispensable reference to European bookhands at the moment of their crystallization into print.

Child, Heather (ed.). *The Calligrapher's Handbook.* A. & C. Black, London, 1985. (First published by

Faber and Faber, 1956.)

Degering, Hermann. *Lettering.* Benn, 1965.
Excellent manuscript examples included,
chronologically arranged.

Fairbank, Alfred. *A Handwriting Manual.* Faber,
1932.
The standard illustrated introduction to the italic
hand.

Forde, Helen. *Domesday Preserved.* H.M.S.O.,
1986. *Domesday Rebound* (1954) updated.

Gardner, William. *Alphabet at Work.* A. & C. Black,
London, 1982.
A survey of the design and use of alphabets today.

Hart, H. *Rules for Compositors and Readers at the
University Press Oxford.* 39th ed., Oxford
University Press, 1983.
Exhaustive guidance.

Hector, L.C. *The Handwriting of English
Documents.* Arnold, 1958.
An authoritative and well-illustrated account of
official manuscript archives, mainly at the Public
Record Office, London.

Henry, Françoise. *The Book of Kells.* Thames and
Hudson, London, 1974.
Essential reference, tracing its links with the
Lindisfarne Gospels, for this greatest achievement of
early manuscript work.

Johnston, Edward. *Writing, & Illuminating, & Lettering.* John Hogg, London, 1906. (Subsequently Pitman and A. & C. Black.)
The great standard work and main source of the modern revival of calligraphy.

Johnston, Edward. *A Book of Sample Scripts.* H.M.S.O., 1966.
Facsimile of a manuscript commissioned by Sir Sydney Cockerell now in the Victoria and Albert Museum.

Johnston, Edward (Ed. Heather Child). *Formal Penmanship.* Lund Humphries, London, 1971.
Edward Johnston's exhaustive postcript to *Writing, & Illuminating, & Lettering.*

Johnston, Edward (Ed. Heather Child and Justin Howes). *Lessons in Formal Writing.* Lund Humphries, London, 1986.

Ker, N.R. *English Manuscripts of the Century after the Norman Conquest.* Clarendon Press, Oxford, 1960.
The Lyell Lectures of 1952-3. See especially Part VI – 'Scribal Practices' – and the splendid plates.

Lowe, E.A. *The English Uncial.* Oxford University Press, 1960.
The standard illustrated study of the subject.

Mahoney, Dorothy. *The Craft of Calligraphy.* Pelham Books, 1981.
Testimony of one of Edward Johnston's assistants.

Morison, Stanley. *Black Letter Text*. Cambridge University Press, 1942.
The best and most scholarly study. Well illustrated. (Only 100 copies printed.)

Ogg, Oscar. *Three Classics of Italian Calligraphy*. Dover, New York, 1953.
The copy books of Arrighi, Tagliente, and Palatino, with all their sixteenth-century panache.

Osley, A.S. (Ed.). *Calligraphy and Palaeography*. Faber, 1965.
Festschrift – some three-dozen tributes to Alfred Fairbank.

The Oxford Dictionary for Writers and Editors. Clarendon Press, Oxford (revised 1982). Essential reference.

Parkes, M.B. *English Cursive Book Hands 1250–1500*. Scolar Press, 1979.
A recent well-illustrated account of researches by the Lecturer in Palaeography in the University of Oxford.

Publications of the Palaeographical Society and of the New Palaeographical Society – 1873–1930.
Exhaustive coverage of European bookhands. Folio volumes of high quality illustrations.

Parkes, M.B. and A.G. Watson (Eds.). *Medieval Scribes, Manuscripts & Libraries. Essays presented to N.R. Ker*. Scolar Press, 1978.
Thoroughly illustrated contributions by

palaeographers to a *festschrift* for a great solver of riddles in manuscript.

Shahn, B. *Love and Joy about Letters.* Cory, Adams and Mackay, 1963.

Society of Scribes and Illuminators. Illustrated catalogue of the 60th Anniversary Exhibition. London, 1981.
The state of the craft amongst English practitioners of the Society.
Catalogues of the Society's exhibitions and its journal, *The Scribe,* illustrate trends in professional calligraphy.

Studio Vista. *Modern Scribes and Lettering Artists.* London, 1981.
230 black-and-white illustrations of current international calligraphy.
And subsequent editions.

Thomson, S. Harrison. *Latin Book Hands of the Later Middle Ages, 1100–1500.* Cambridge University Press, 1964.
First-class detailed discussion of 132 significant examples, arranged chronologically by country.

Thompson, E. Maunde. *An Introduction to Greek and Latin Palaeography.* Oxford, 1912.
The basic history of the subject and the starting point for serious study.

Turbayne, A.A. *Monograms and Ciphers.* T.C. & E.C. Jack, London and Edinburgh, 1906.

Invaluable stimulus. Examples galore.

Publications of the Type Facsimile Society, 1900–1909.
500 examples of mechanized bookhands.

Ullman, B.L. *Ancient Writing and Its Influence.*
Harrap, London, 1932.
Infinitely worth a critical reading.

Index

Printed in Great Britain at the University Press, Cambridge